IMAGES
of America

CHATHAM
TOWNSHIP

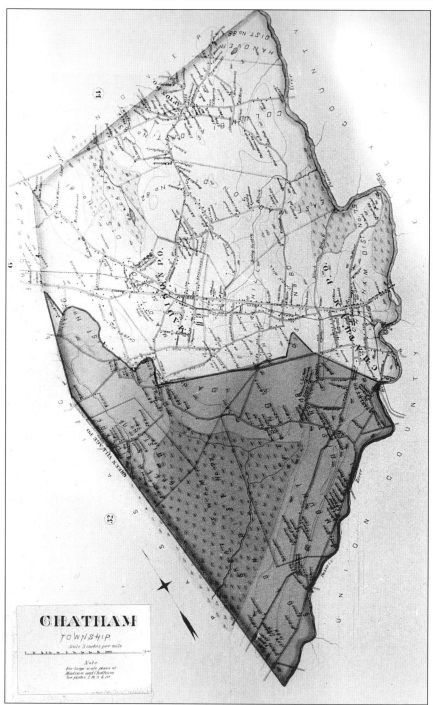

In this map of Chatham Township, from Robinson's *Atlas of Morris County* (1887), it is easy to see the great chunk that split away between 1889 and 1899 to form Chatham Borough, Madison Borough, and Florham Park Borough (called Afton Post Office until 1899). The remainder, with a dark tone to define the modern size and shape, shows how the once-large municipality was diminished to its present size of about four square miles.

IMAGES
of America

CHATHAM
TOWNSHIP

John T. Cunningham

ARCADIA

Published by Arcadia Publishing,
an imprint of Tempus Publishing, Inc.
2A Cumberland Street
Charleston, SC 29401

Printed in Great Britain.

Library of Congress Catalog Card Number: 2001089158

For all general information contact Arcadia Publishing at:
Telephone 843-853-2070
Fax 843-853-0044
E-Mail sales@arcadiapublishing.com

For customer service and orders:
Toll-Free 1-888-313-2665

Visit us on the internet at http://www.arcadiapublishing.com

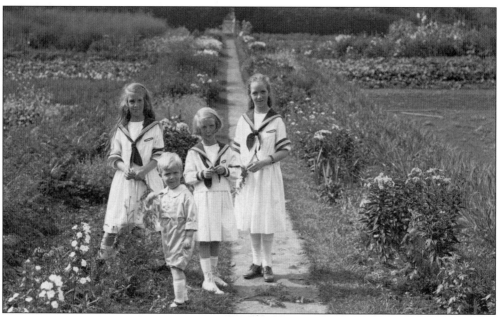

Three of the Averett children pose prettily in the 1920s on a walk at Dixiedale, the family's noted farm on the hill overlooking the Passaic River. This photograph is from a handsome family album loaned to the author by Samuel Averett, a brother to the three girls shown.

On the cover: Dr. John Dorning sits under a shade tree to read to four Averett family children. Bettie Averett stands on the left. Her two sisters, Janie and Martha, stand on the right with their brother Elliot Averett.

CONTENTS

ACKNOWLEDGMENTS

Many people assisted in preparing this pictorial history of Chatham Township, an area long neglected by researchers. I am especially grateful for the many days given to the project by Chatham Township Historical Society colleagues, who are pictured below.

Ken Birch, who worked tirelessly in copying photographs, and Andrew Bobeck (of Chatham Borough), who has worked closely with me on several Arcadia books, were foremost in preparing photographs. Leading those who opened their picture files to us were Mr. and Mrs. Samuel W. Averett, whose photographs of Dixiedale appear throughout the book; Mr. and Mrs. William Horton, for the Diefenthaler photographs; Bailey Brower Jr., who loaned photographs and memories of Noe Farm; Bette Ann Bey Smithbauer, granddaughter of Rustem Bey, who loaned photographs and research materials to Caroline Knott; Beatrice Gritzan, Blanche Thorner Blumenfeld, Beatrice Katz Philwyn, and Bert Abbazia, for materials on the Colony Association; Art and Val Heyl, for help in getting material on Green Village and their historic rose business; Tony and JoAnn DeBiasse, for photographs of the Behre greenhouses and modern Hickory Tree shopping center; and Jim Del Guidice, for several beautiful photographs of the township's historical buildings.

We also are indebted to the Chatham Township Police Department; the Long Hill and Green Village Fire Departments; the Madison Public Library; the Joint Free Public Library of Morristown and Morris Township; the Newark Public Library; the Morris County Heritage Commission; Blaine Rothauser, for the Great Swamp animal photographs; Bill Kotch, manager of the Great Swamp National Wildlife Refuge; Cam Cavanaugh; Gertrude Zander; Jack Kostibos; Jim Fiala; Suzanne Hegarty; and Nila Sodano.

—John T. Cunningham, spring 2001

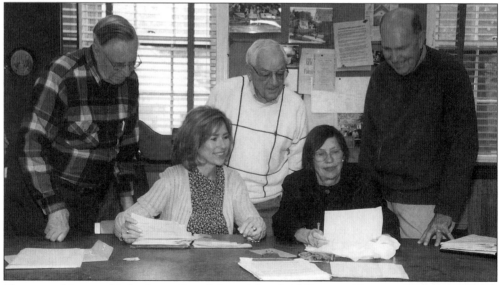

Shown working on this book are, from left to right, the following: (front row) Marianne Felch and Caroline Knott; (back row) Kenneth Birch, John T. Cunningham, and Donald Engesser. Nancy Vroom also assisted this group.

INTRODUCTION

Chatham Township, founded in 1806, endured its first 150 years in relative obscurity. Its major achievement in that century and a half was as the mother of three thriving boroughs—Madison, Chatham, and Florham—all of which seceded from the township between 1889 and 1899 to pursue independence.

Transportation improvements in the early 19th century foreordained the township's lack of recognition. In 1801, five years before the founding of the township, a major east-west toll turnpike crossed the Passaic River at Day's Bridge and headed toward prosperous Morristown via the village of Bottle Hill (now Madison). As an ironic bit of solace, a road south of the turnpike became a magnet for travelers wishing to avoid turnpike tolls. Its nickname, the Shunpike, persists in a modern Chatham Township road.

The Morris & Essex Railroad laid its tracks to Morristown in the late 1830s via Madison, after seriously considering a route through Chatham Township. The township became so far off the beaten track that it might as well have been nonexistent. By 1899, thanks to the secession of the three large areas cited above, the township had shrunk to about a quarter of its original size, and nearly all of its early history was enveloped by the history of the three seceded municipalities.

Bound by the Passaic River on the east and the Great Swamp on the west, rural Chatham Township was dominated by a few large farm owners. William Gibbons, whose large Madison estate became the Drew University campus in 1867, maintained a huge horse farm on Race Course Lane (now Noe Avenue). One of his horses, Fashion, became the greatest racing mare that this nation has ever known. Lewis M. Noe, whose Huguenot ancestors had come from France in 1663, established a farm along Southern Boulevard before the American Revolution. Noe's farm grew to such prominence, particularly because of its large rose-growing greenhouses, that it became virtually a village within itself. Green Village—settled near the edge of the Great Swamp long before old Chatham Township was established as a separate entity—was the nearest thing to a genuine municipality that the township ever had. It consisted of a few houses, a Methodist church, a firehouse, and at one time a basket factory and a sawmill.

About a mile north of Green Village lay the crossroads hamlet called Hickory Tree, named for a towering hickory tree that rose above a small building at the corner of Southern Boulevard and the Shunpike. Near the intersection, a huge greenhouse complex that was built in the late 1920s by rose grower Edward Behre fell a victim to the Great Depression. All traces of the greenhouses disappeared when the Hickory Tree shopping center was built in 1969.

Undoubtedly the best-known portion of Chatham Township before World War II was Madame Bey's training camp for professional prizefighters. Some of the nation's best-known boxers, including Jack Dempsey, Max Schmeling, Mickey Walker, and Gene Tunney, trained at Madame Bey's for nationally publicized championship fights. It was common to see a world champion sweating through conditioning miles run along River Road in the rising morning mists. Madame Bey, well educated and musically talented, came to the United States c. 1900, the Armenian wife of a Turkish diplomat. She became a major personality in both diplomatic circles and in the less glamorous but far better publicized sports world. Her successor, Ehsan Kuradag, opened the camp to train Kid Gavilan, Floyd Patterson, Sugar Ray Robinson, Jim Braddock, Ezard Charles, Rocky Graziano, and "Jersey Joe" Walcott.

Outdoor enthusiasts from a wide area doted on the Great Swamp, a remnant of crushing glacial ice that covered the area about 150,000 years ago. As the mile-high icecap moved back toward the Arctic Circle about 40,000 years ago, it left behind Lake Passaic as a memento. The lake stretched about 25 miles north and south and was up to 10 miles wide and, in some places,

240 feet deep. As the lake drained away, its major evidence was the vast region called the Great Swamp.

For many decades, the swamp area was heavily timbered. Early Native Americans used wood from the swamp. In the early 20th century, the area attracted sawmill owners, who sliced logs into timbers and other kinds of lumber. Farmers cut wagonloads of hay from the swamp's broad meadowlands. Large stretches of water and treacherous soil made travelers wary. Local people who knew their way through the bogs returned in summertime with bucketfuls of huckleberries. Sportsmen hunted and trapped throughout the region and trained their hunting dogs in the far reaches of the swamp. Despite such respect by those who frequented the swamp, the region was scantly regarded; garbage dumps on the swamp's periphery were making the area unsightly by the 1950s. Chatham Township's day of reckoning came on December 14, 1959, when the front pages of the late-afternoon editions of the *Newark Evening News* trumpeted a startling story beneath a bold headline: JETPORT PLAN UNVEILED. The Port of New York Authority, the story said, would spend $200 million to turn 10,000 acres of the Great Swamp into an international jetport. Residents from many towns encircling the swamp reacted quickly and vehemently. The retaliatory battle centered in Green Village, where the first organized counterfight began. The anti-jetport battle eventually reached as far as Washington, D.C. The Port Authority was soundly repulsed and, instead of a jetport, the swamp became a major wildlife refuge.

Chatham Township had finally made the front page. In the wake of the jetport battle, many housing developments accelerated in the township, vividly changing the look and nature of the once-rural sections. Still, Green Village is the only definable town (and it has changed very little through the years). If there is a Chatham Township center, it might well be the Hickory Tree shopping center. If one is seeking a heart, however, it beats in the Red Brick Schoolhouse, at the corner of Fairmount Avenue and Southern Boulevard, home of the Chatham Township Historical Society.

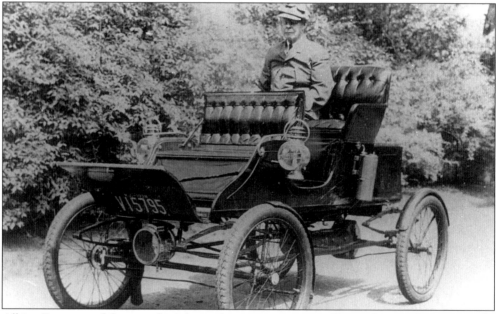

Albian Page, one of the township's better-known icons, enjoyed being first in whatever caught his fancy—such as this very early Stanley Steamer automobile. It became a familiar sight on the dirt (and, in springtime, very muddy) thoroughfares.

One
THE BASE OF HISTORY

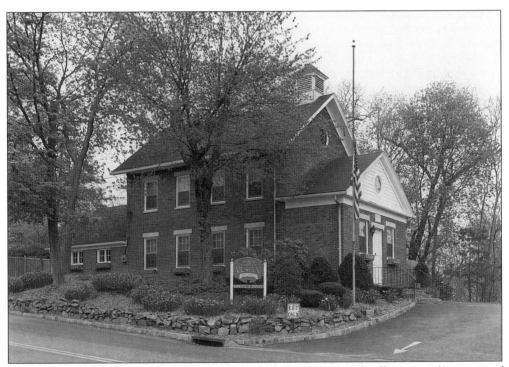

The historical heart of Chatham Township is in the Red Brick Schoolhouse, at the corner of Fairmount Avenue and Southern Boulevard. The two-story structure, known in its operating days as Mount Vernon School, opened in 1860 and served as an educational center until 1928, when a newer school on Southern Boulevard replaced it. In 1958, the old building was deeded to the township for use as a municipal building. Thirty years later, the Chatham Township Committee authorized the township's historical society to use the building as its museum.

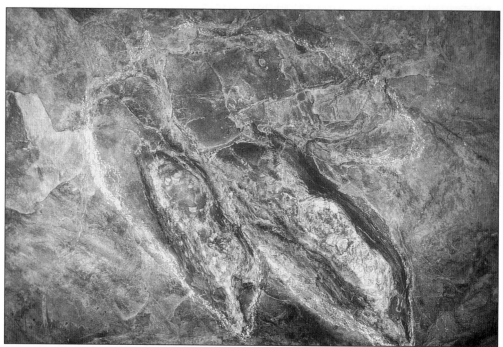

Township history begins with the clear, fleur-de-lis-shaped dinosaur footprint (above) that was found in the Great Swamp on Memorial Day weekend in 1979 by Duncan Hallock and his son Scott (below). Duncan, a former science teacher, recognized the print as a dinosaur track. It later was identified as the footprint of a Coelophysis, a small, carnivorous dinosaur that ambled through the swamp area about 180 million years ago.

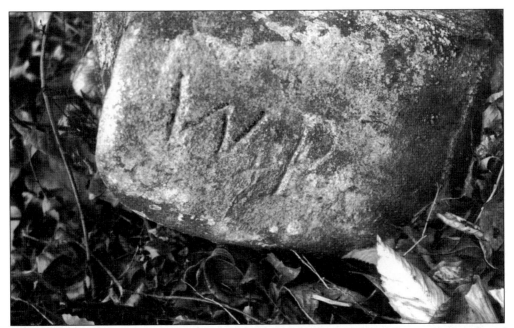

About 180 million years after dinosaurs roamed the marshes, William Penn, the founder of Pennsylvania, acquired land in the same region. This stone, apparently a property marker, clearly shows the initials W.P., identifying the noted Quaker as the owner. It is estimated to be more than 300 years old. This is one of two Penn markers in the Great Swamp area.

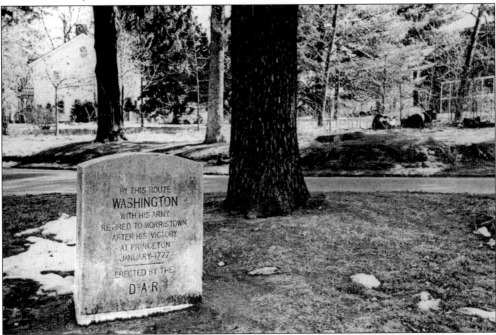

Shortly after Gen. George Washington soundly defeated British troops in Princeton on January 3, 1777, he led his battle-weary soldiers northward to Morristown, passing through Green Village on the way. The Daughters of the American Revolution erected this tablet to preserve the memory of the march through the village.

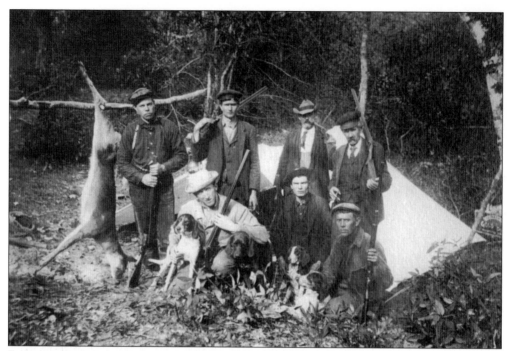

Except in summertime, when women joined men in seeking huckleberries in the marshes, the Great Swamp was a men's reserve. Shown during a deer hunt, the group above includes, from left to right, the following: (front row) Isaac Noe, unidentified, and Louis A. Noe; (back row) J. Leon Doremus, unidentified, DeWitt Whittlesey, and unidentified. Somewhere in the swamp in pre-Prohibition days, the whiskey-making still shown below turned out alcoholic beverages for those eager to taste home-distilled whiskey.

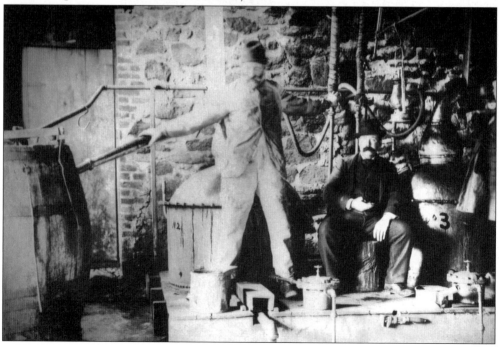

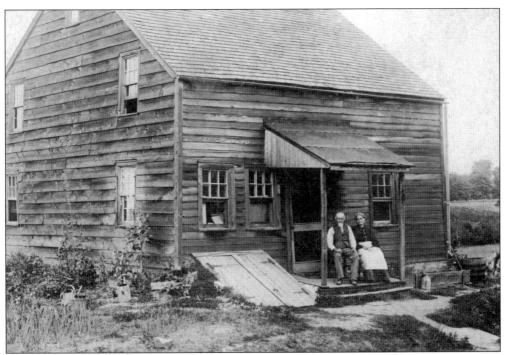

One of the township's earliest homes was the Kammerer house, located on Meyersville Road near Fairmount Avenue. Shown above c. 1907, the plain clapboard house was built in the 19th century. Below, Frederick Kammerer and his wife wait patiently c. 1910 for a photographer to capture their images with a small box camera.

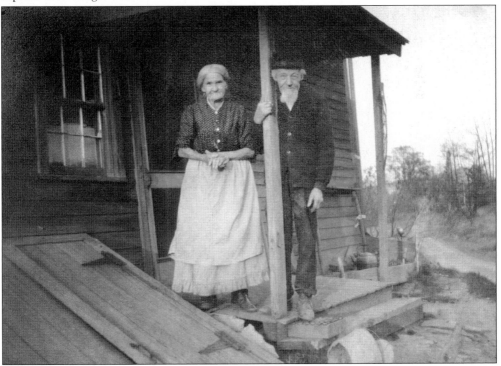

Proof of early settlement is found in the four houses displayed on these two pages. The so-called Baldwin-Price House (above), at 48 Southern Boulevard, is an elegant farmhouse built in the late 18th century. Its distinguishing feature is the beehive oven, seen in the lower right section of the photograph. The surrounding 49 acres were operated as a farm by the Price family.

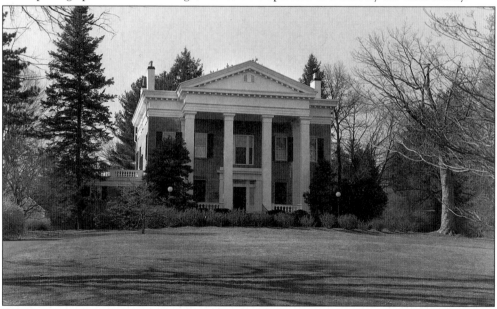

This massive, three-story Greek Revival brick house known as the Boisaubin Mansion is at 95 Treadwell Avenue. It was built c.1822 for Vincent Boisaubin, a French nobleman who fled France before the French Revolution. His Chatham Township house was surrounded by a 200-acre farm plantation. Arthur J. Treadwell, an avowed abolitionist, owned the house from 1851 to 1880, lending credence to the belief the mansion was a stop on the Underground Railroad.

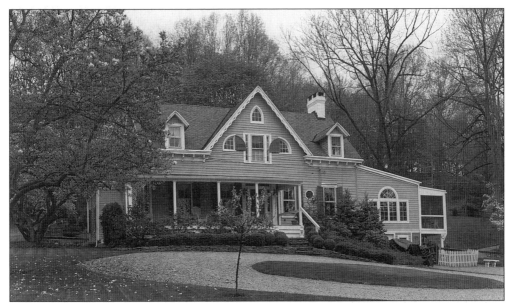

The Gabriel Johnson House, at 805 Fairmount Avenue, was built *c.* 1790 by the Johnson family. Four fireplaces in the cellar indicate that the family lived in the lower part of the house while the upper part was being built above them. The old plaster is bonded with human hair. An early-19th-century hydraulic ram water system that supplies running water to the kitchen, milk room, and attic is still working. A friendly ghost has allegedly been sighted many times in the house.

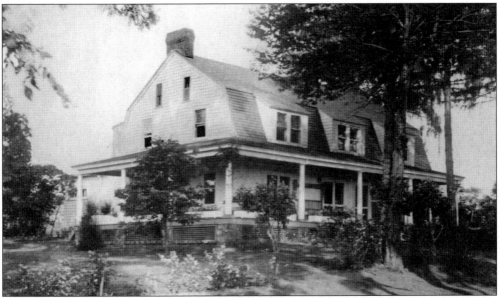

Philomen Dickinson, listed in a 1771–1772 census as a voter in Morristown, built this house shortly before 1770. The broad porch and the dormers in the gambrel roof were later additions. Philomen's son Peter was born in the house in 1770 and lived there until his death in 1840. Another family member, Caleb Dickinson, lived in the house until 1880. The place is sometimes called the Diefenthaler House for G.E. Diefenthaler, who bought the house and farm in 1917.

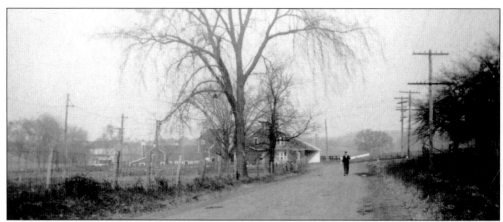

This picture of old Southern Boulevard (these days one of Chatham Township's main thoroughfares) was taken sometime before World War I. Although it was an important road that carried traffic between Madison and New Providence, the street was little more than a dirt road that jolted riders in wagons, carriages, and farm vehicles. Foot travelers enjoyed the sparsely used road.

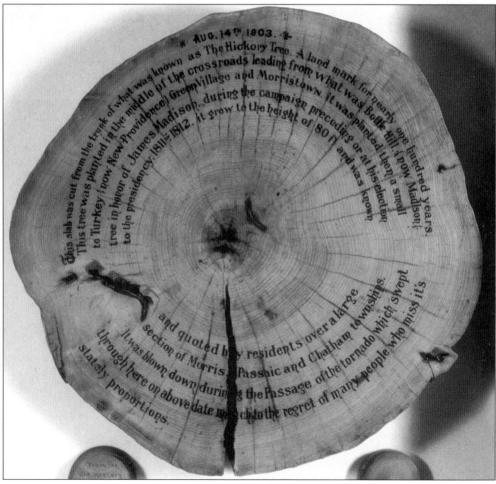

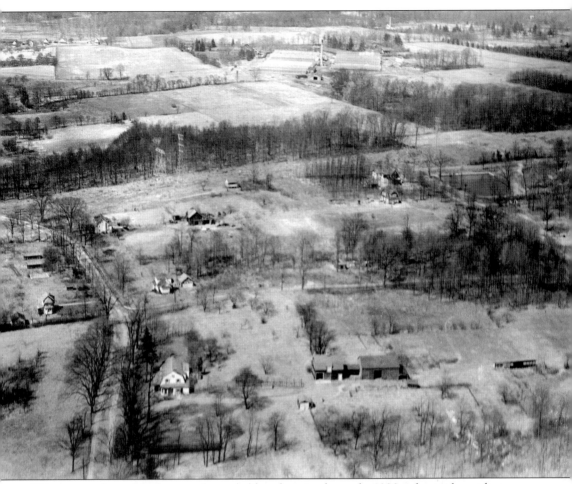

This very early aerial photograph, probably taken in the early 1920s, shows the wide open spaces of a township that would not catch the eyes of homebuilders and property developers for another half century. In the foreground is the Diefenthaler farm.

Left, bottom: In the beginning of the 20th century, there really was a hickory tree at the intersection of Green Village Road and Southern Boulevard. The area is still called Hickory Tree. This slab from the tree, displayed in the historical society's museum, tells the story. Planted in 1811 or 1812, the tree honored Pres. James Madison. It grew to a height of 80 feet, but on June 14, 1903, a tornado felled the symbol, "much to the regret of many people who miss its stately proportions."

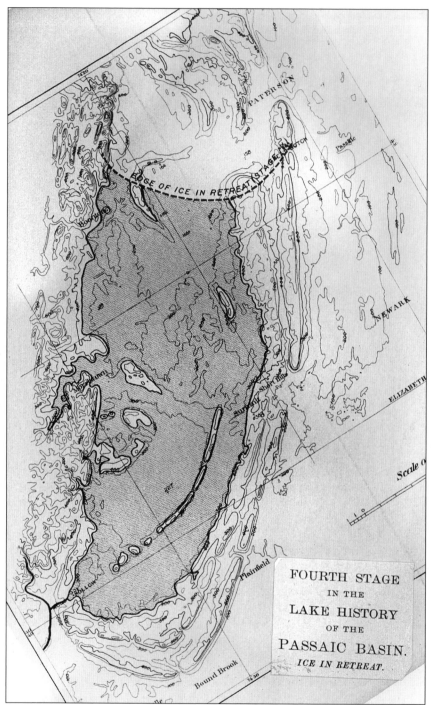

This map of Lake Passaic, re-created in *The New Jersey State Geological Survey* in 1903, shows the extent of the mighty prehistoric lake that remained after the retreat of the last glacier over northern New Jersey. The lake stretched as much as 25 miles north and south and was up to 10 miles wide. When the glacier melted northward, the lake water drained away and left the Great Swamp as a memento for humans yet to come.

Two

THE GREAT SWAMP

This green frog represents the fauna and flora of the Great Swamp and symbolizes the ecological fervor that swept across the area in the holiday season of 1959. Disaster loomed, disguised in the goodwill cloak of the Port of New York Authority, which promised to pave over more than 10,000 acres of the swamp to create a giant international jetport. In addition to threatening one of the finest wetland drainage areas on the East Coast, the mere thought of huge jetliners rising from and landing on long runways stunned the region. People in all walks of life rose in wrath, including a majority of residents who had seldom given the swamp a thought and probably believed it to be a dank nuisance. Thus, when the Port Authority's threat led ultimately to a protected National Wildlife Refuge, the aborted-jetport fiasco became one of the greatest gifts ever bestowed on the community.

Jetport Pl

Ike in Athens

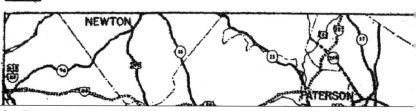

A bomb dropped on the Great Swamp could not have created greater anger and concern than this bold headline in the *Newark Evening News* on December 14, 1959. Phrases in the article, such as "$220 million," "10,000 acres," and "Jetport Plan" stirred both panic and determination

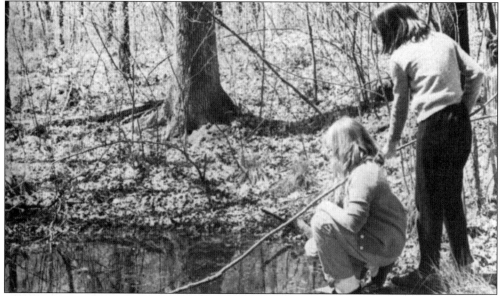

Many residents who, before the threat, might have thought the Great Swamp was a perfect receptacle for garbage began thinking of the area as a refuge for children, bird watchers, nature lovers, animals, and flowers.

n Unveiled

Morris Site
PA's Choice

to battle one of the most powerful nongovernment agencies in the United States. Resident telephones buzzed until long after midnight, planning a counterattack.

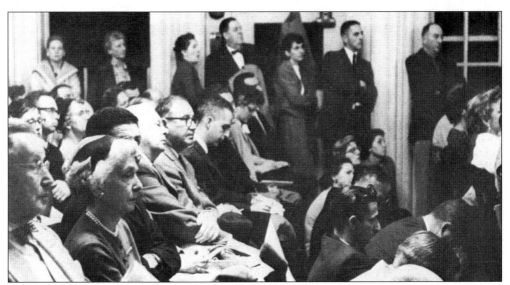

They gathered together—the rich, the poor, the nature lovers, and the noise haters—in nearby Madison High School's auditorium, the only central space large enough to hold the many angry, bewildered people seeking to join the fight against the Port of New York Authority.

21

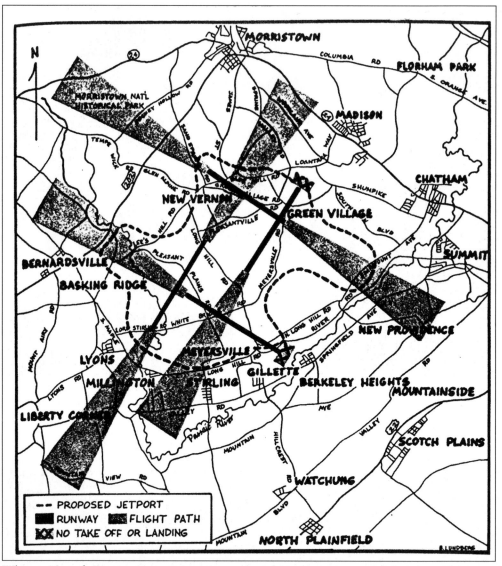

When a *Newark Evening News* artist put together this schematic map of the planned jetport, opposition rose to fever pitch. The proposed runways centered near Green village were enough to fan indignation, but the broad flight paths suggested potential damage to the Morristown National Historical Park and towns such as Florham Park, New Vernon, Millington, Stirling, New Providence, Madison, and Chatham.

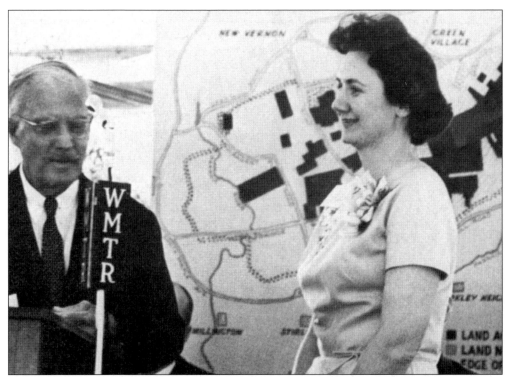

The initial flaring anger settled down into a long, hard war of hearings at county, state, and federal levels. The conflict also became a grass-roots endeavor, led by Helen Fenske, a young, Green Village housewife and mother who fervently believed citizens must be educated to love the swamp. She and her neighbors kept the action going until major money could be found to buy swamp acres. Warren Kinney (left), honorary co-chair of the Great Swamp Committee, singled out Helen for special recognition on Dedication Day in May 1964.

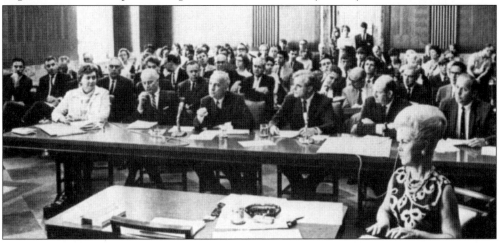

At one of the many hearings on preservation of the swamp, the Port Authority coolly insisted that the jetport's creation of jobs and additional commerce would offset any ecological or aesthetic negatives. Some politicians and labor unions joined the Port Authority when it boldly counterattacked at state and federal hearings. One such hearing (shown) was held at Drew University, where a U.S. Senate subcommittee heard testimony.

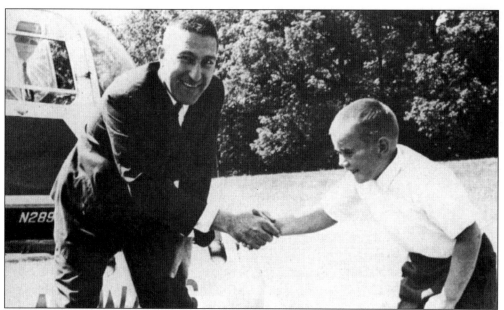

On May 29, 1964, Secretary of Interior Stewart L. Udall (shown) came from Washington, D.C., to attend the dedication ceremony of the first portion of the Great Swamp as a National Wildlife Refuge. He was greeted by Helen Fenske's son Mark. That day, the Great Swamp Committee formally presented 2,600 acres of land, valued at more than $1 million, to the federal government. Gifts to that point had come from 462 organizations, 6,100 individuals, 286 towns, and 29 states.

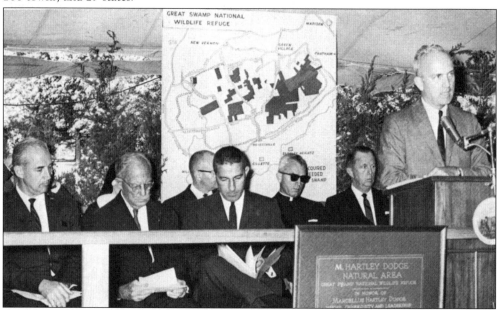

Congressman Peter H.B. Frelinghuysen (at the podium) said the dedication would encourage groups "all over the United States who hope to save a river, or a forest, or a marsh." The other speakers are, from left to right, John S. Gottschalk, Federal Bureau of Sport Fisheries and Wildlife; Warren Kinney, Great Swamp Committee; Secretary Udall; Rev. George Nierieman, New Vernon Presbyterian Church; and Sen. Thomas Hillery.

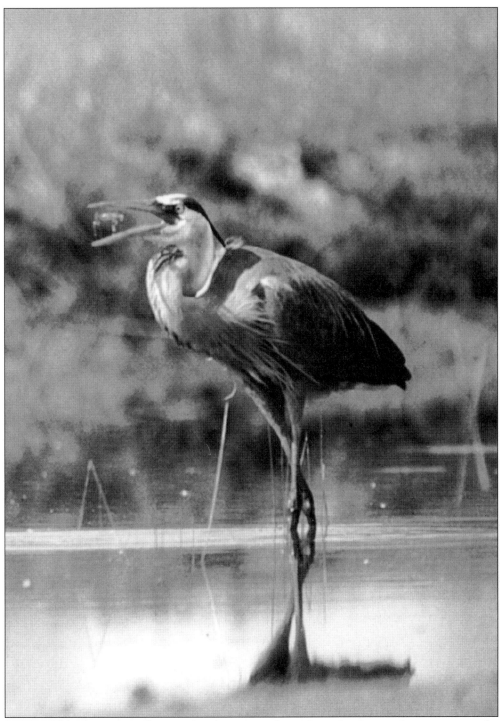

The great blue heron, usually considered a native of seaside wetlands, quietly came to join the flocks of birds that settled into the Great Swamp. The heron has become the symbol of success for everyone who has worked for preservation of the historic and ecologically rich refuge.

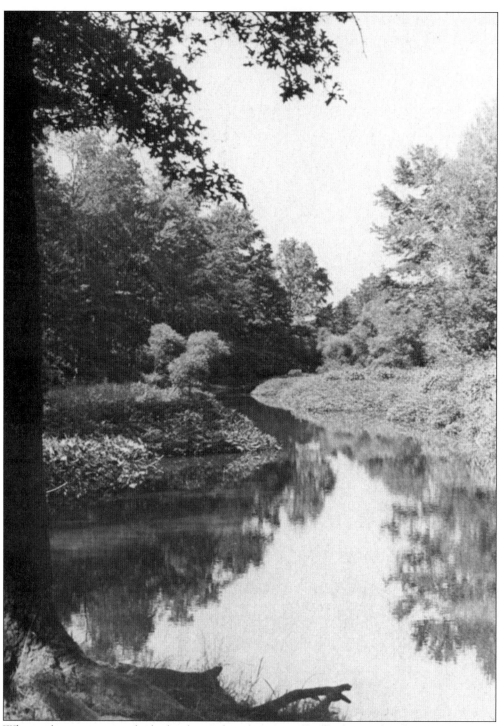

When it became time to look closely at what the great effort had wrought, there was much to see. Four brooks like this one cross the area, flowing slowly through the marshlands and past open fields and tall forests. In 2000, the Great Swamp comprised more than 7,500 acres—revered as a place of primal beauty rather than as a place of feared dankness.

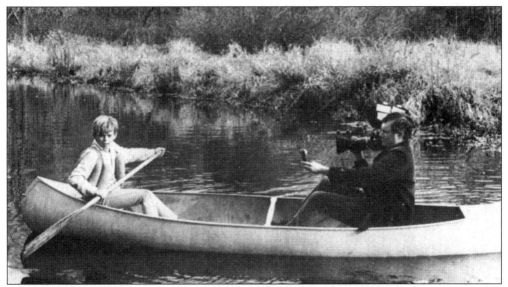

Improvements in the Great Swamp holdings brought visitors in automobiles, on foot, and in canoes and other watercraft. The photograph above was taken during a television program shot during the height of the campaign to promote the area as a place of beauty and charm in the midst of a great urban region. As shown below, bicycle paths also attracted visitors.

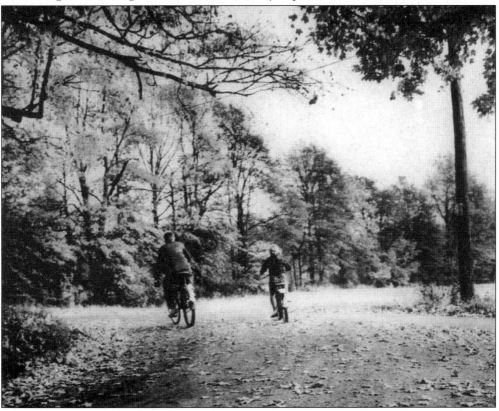

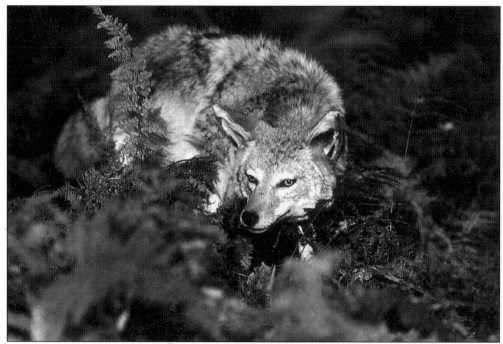

For those who could see and knew where to look, the eyes of swamp denizens peered furtively at strangers in the Great Swamp. The photographs on these two pages (all taken by Baine Rothauser) emphasize the watchful eyes and then focus on the animals. A coyote (above) warily tries to sleep, and a pair of cautious raccoons (below) investigate before climbing over a log.

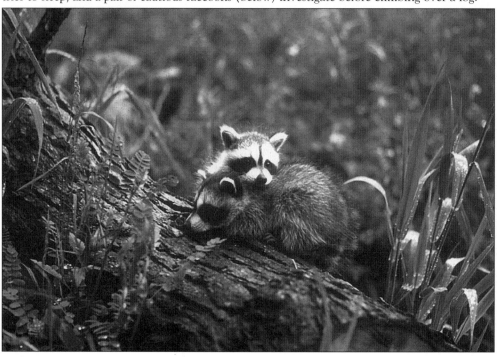

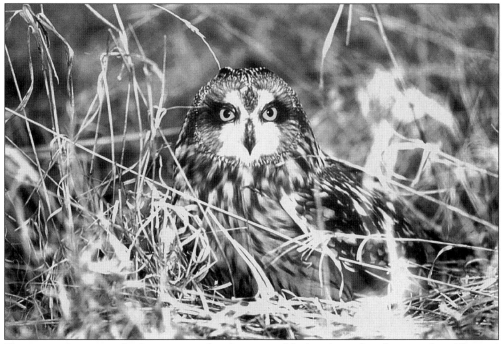

Two representatives of a fierce raptor family stare unblinkingly at the photographer. The owl (above) was unequivocal about the Great Swamp: it was his. Equally protective of his land was the northern harrier hawk (below). Each must use the eyes for its own existence, as do dozens of other bird species that call the Great Swamp home.

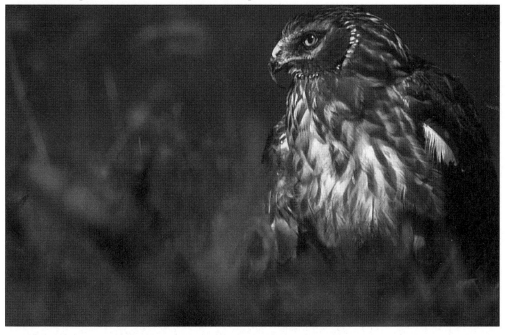

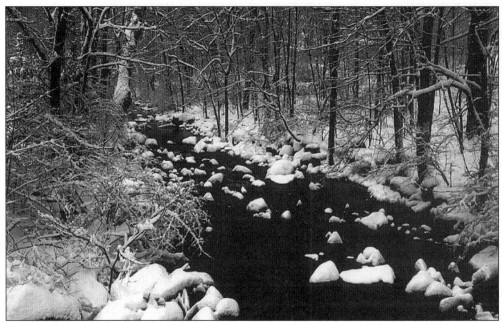

Whether it is the broiling sun of summer, the mellow blue skies of May and October, or the depth of winter, the Great Swamp is a place for all seasons. When the snow begins to melt (above) in the bogs and meadows, the voice of the spring peeper (below) is heard in the land.

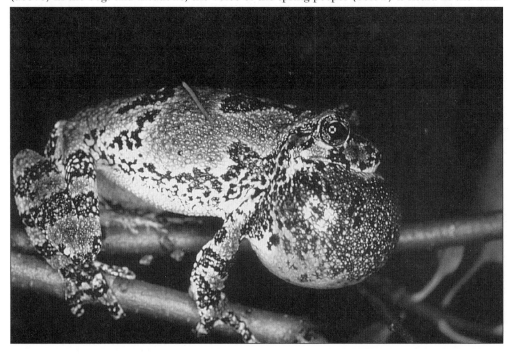

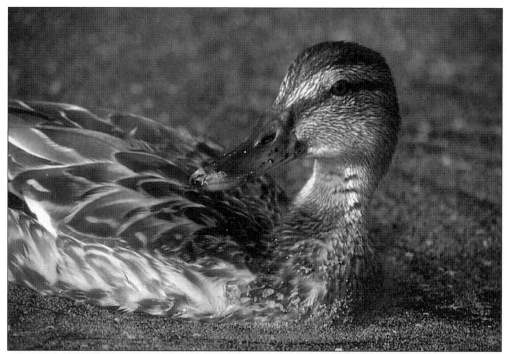

Impounded water has intensified concentrations of waterfowl, both year-round varieties and migrating birds that visit in spring and autumn. Waterfowl species range from mallards (above) to omnipresent Canada geese (below). More than 150 species of birds, including spring and fall migrants, have been seen in the refuge.

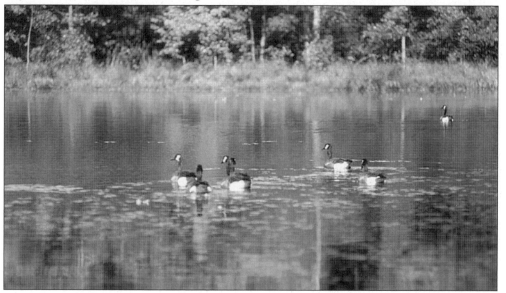

Helen Fenske, who rallied Green Village residents to the anti-jetport cause, can recount tales of the primitive slide show that she and friends staged countless times in the early days to keep the threatened Great Swamp in the public eye, although she looks to the future more often than to the past. She has fought the great fight against complacency for more than 40 years and is recognized as one of the most committed conservationists ever known in New Jersey.

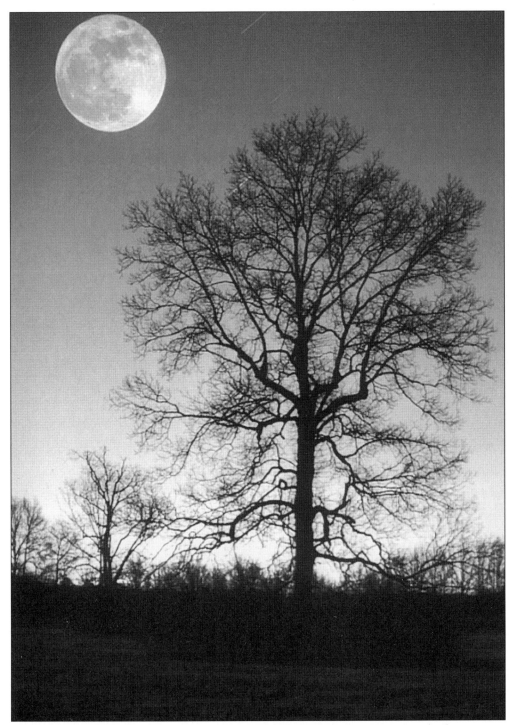

An autumnal full moon casts an eerie glow across the Great Swamp, bringing back memories of distant days when sportsman from a wide area surrounding the swamp brought their hounds to train them to follow a scent. Those who sat in on one of the nocturnal training sessions will never forget the sound of disciplined dogs baying in the distance.

Wooden boardwalks now thread through some parts of the swamp, allowing visitors the chance to see nature up close. Beside the boardwalks, the first spring flowers appear and frogs and other small animals can be seen. Huge flocks of migrating birds descend on the ponds, headed northward in spring, southward in the fall.

Three

THE GREENING
OF A VILLAGE

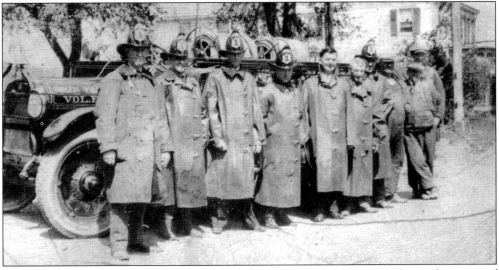

Green Village has been known since before the American Revolution; a marker in the center of town tells of American soldiers passing through on the way to Morristown in the winter of 1777. When noted gazetteer Thomas F. Gordon passed through in the early 1830s, he described the place as having "five or six dwellings, situated in a pleasant, fertile country." He did not mention that it was also the settlement closest to the Great Swamp. Outward from the village stretched the pastures, vegetable fields, and apple and peach orchards that supported the economy.

No one has ever described the village as a focal point of American history, but it typifies an increasing rarity: a settlement that retains much of the character that made it worth settling. It has known moderate residential growth through the centuries, has seen shopkeepers prosper in small establishments along the main street, and has heard the bustle of lumbering companies and the buzz of sawmills. It pioneered Chatham Township's first school and first fire department. The latter, shown here in 1928, has always been a center of village social life.

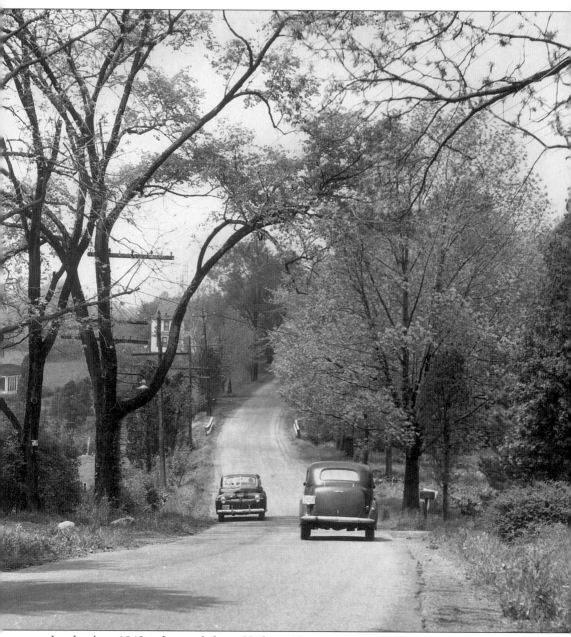

In the late 1940s, the road from Hickory Tree to Green Village was primitive. It was macadamized, but the edges had sharp drop-offs on each side. The *Newark Sunday News*, where this photograph appeared, called the shaded, gently sloping road "a place of beauty."

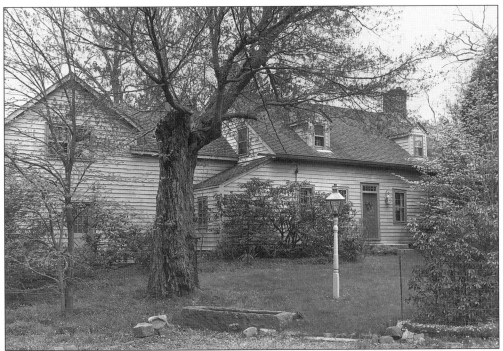

One of the earliest and least altered homes in the township is the Elias Boudinot House, at 461 Green Village Road. Boudinot has been called the first president of the United States, because he was president of Congress when it adopted the U.S. Constitution. The house features solid framing, wide floorboards, and varied woods used as trim. A legend says that American soldiers hid ammunition in a shed on the property during the American Revolution.

A postcard, probably from the 1920s, reveals Green Village to be a well-settled community arrayed beside a wide, dirt main street. Children played on the village green near the school and the Methodist church. Most houses were small, but enough large, two-story Victorian homes were interspersed along the street to create an air of prosperity.

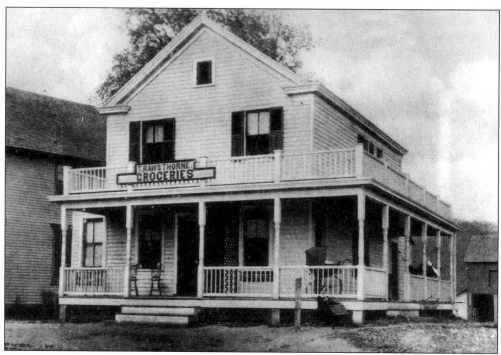

The self-sufficiency of a village before World War I could be measured by whether it had a good general store, where nearly every commodity could be bought, and a blacksmith shop, where any iron product could be fashioned. T. Rawsthorne's Grocery (above), located at 530 Green Village Road, provided the commodities on the ground floor of his house, and Blazier's smithy (below) is on the far left of the substantial family home to the right.

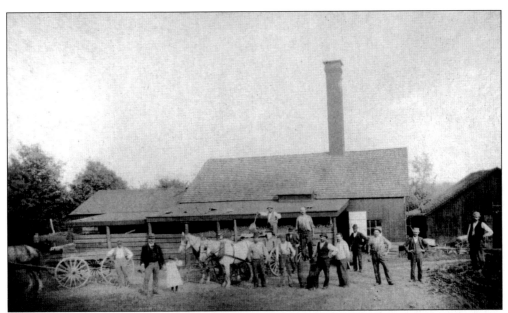

William DeMott came to Green Village in 1881 and soon leased portable sawing equipment to cut lumber in five neighboring counties. Later he built a large mill in town, shown above with most of its workers. The mill made tool handles, wagon materials, and railroad timbers. DeMott later established a basket factory (below), facing the green. He used "off woods" (such as poplar and birch) to make peach baskets as a sideline to the lumbermill.

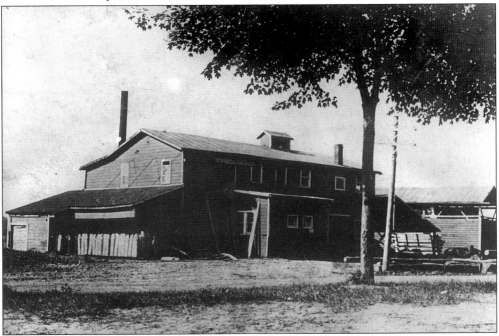

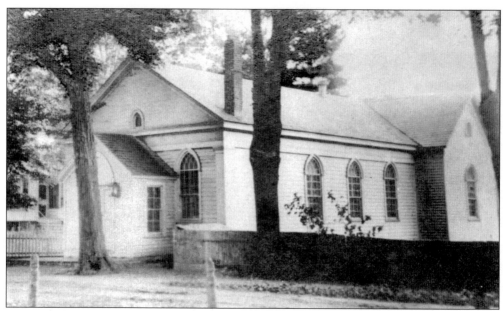

Methodists built this church in 1842. The largest gift, $150, came from William Gibbons of Madison. The church accommodated 175 people, indicating that many out-of-town people traveled long distances to worship. (The church, much remodeled, is now a private home.)

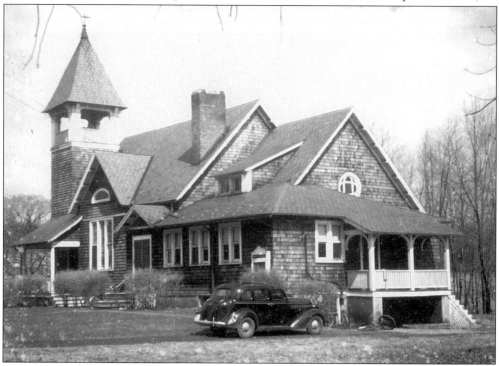

In 1905, Philip Cockrem, a somewhat eccentric farmer, provided the impetus for a new Methodist church when he stipulated that the farm he willed to his widow go to the church after her death. He was not a church member. The larger church had central steam heat and was lit by gas fixtures.

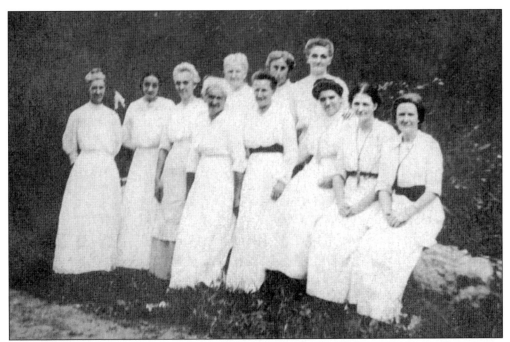

Records show that Methodist church women banded together before 1891 as the Benevolent and Home Missionary Society. It was precursor to the Ladies Aid Society (above), founded *c*. 1900. Members dressed in white gowns for meetings and special occasions.

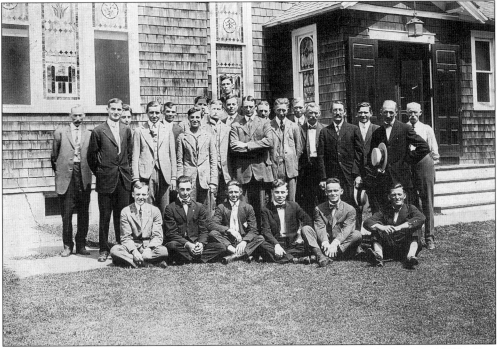

A Men's Class of the Green Village Methodist Church poses sometime before World War II in front of their shingled building. Several stained-glass windows can be seen behind the group. Members ranged in age from very young to some of the oldest men in the congregation.

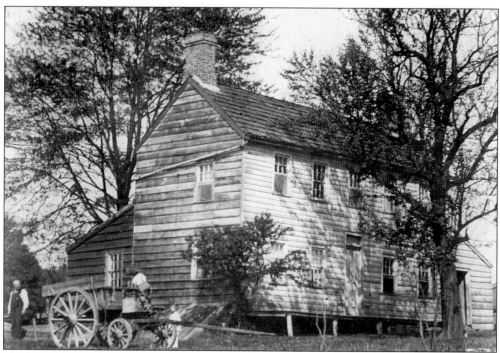

The first known deed for the impressive farmhouse at 330 Green Village Road (above) was written in 1835 in the names of Charles and Phoebe Gilliam. In 1910, the house was acquired by George and Caroline Sutter. The building is therefore known as the Sutter House. The Sutter family memorialized itself and their old house in a postcard (below), printed at an unknown date.

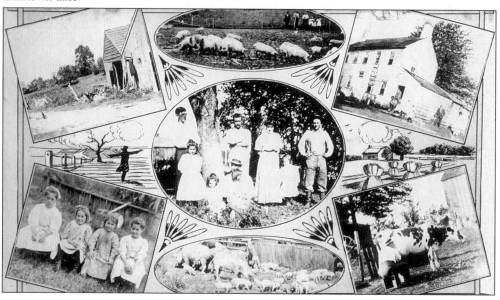

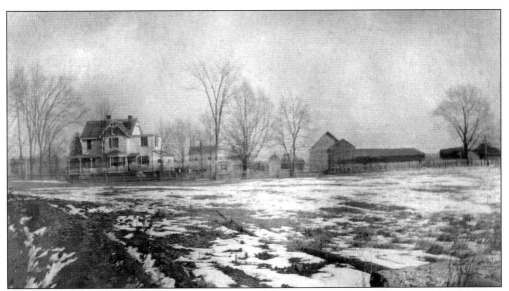

When the village's volunteer fire department decided to build its firehouse in 1922, it acquired part of this broad field (above). The Blazier house can be seen on the far side of the field. On this lot, the firemen built their two-story home (below). Logs were dragged to Daniel Pierson's sawmill, where they were cut into lumber for the construction of the firehouse. Pierson did not charge for his mill's services.

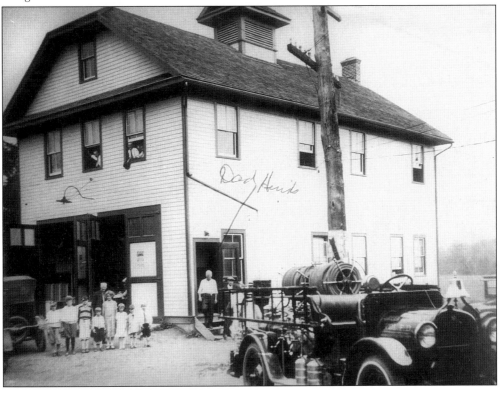

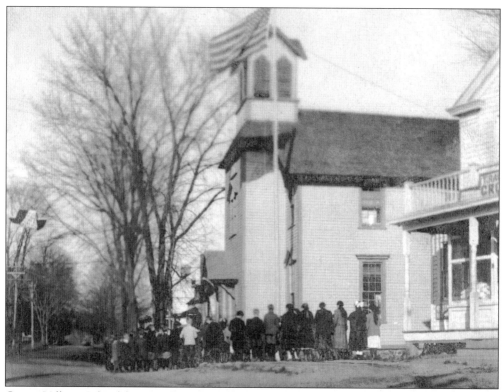

Green Village School boys and girls gather outside their school on November 11, 1918, to celebrate the first Armistice Day. The two-story school, built in 1878, educated grades one through four on the first floor and grades five through eight on the second. About 60 students attended the school each year before it was closed in 1928. The property became privately owned in 1950, housing Botti's Meat Market.

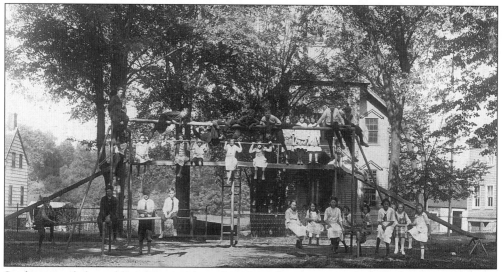

Students used the public playground on the green for recesses and playtime before and after classes began. Boys used swings and other playground equipment on one side of the area. Girls used the other side. Slides in the middle of the green were used by both sexes.

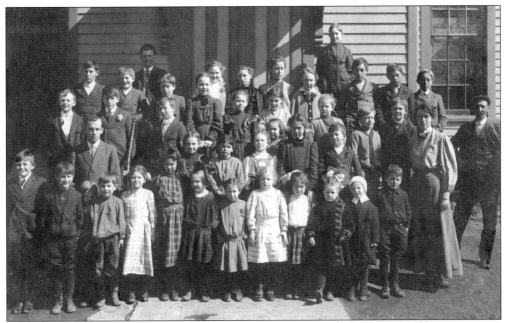

Tradition required that school groups pose for a class photograph on or near the front steps near the end of every school year. The group above met the standard *c.* 1908–1910. The more sedate group below probably represented only the upper grades when it posed in 1916. The later group included such well-known Chatham Township names as Burnett, Blazier, Stiner, Hinds, Sutter, Weber, and Rawsthorne. Villagers know they are a part of Chatham Township, but they take pride in their town.

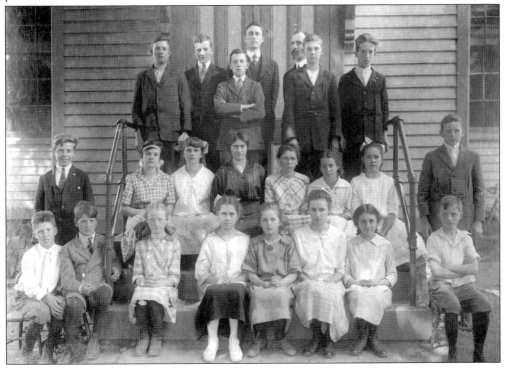

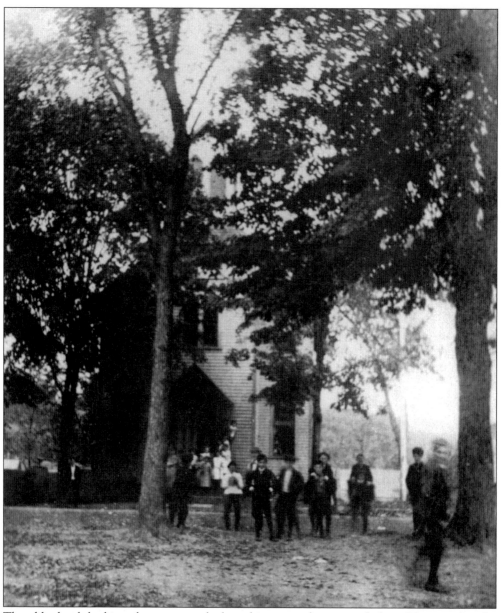

The old school, looking almost pastoral when this postcard was issued about 25 years after the school was built (1878), was considered one of the places to see in quiet Green Village. Few of its students went to high school in an era when an eighth-grade diploma was considered sufficient for farm boys and girls.

Four

An Extended Family

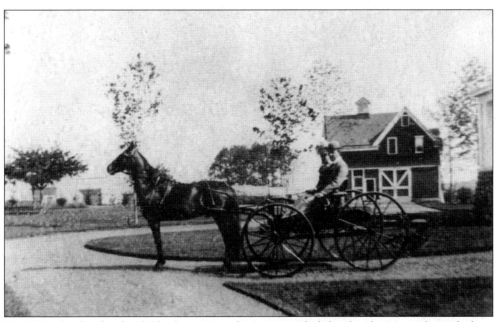

By 1900, the farmlands of Chatham Township's patriarchal family, the Noes, fronted along Southern Boulevard for a long distance. On the gentle slopes, as many as 350 cows grazed, creating milk for the large Noe dairy. Greenhouses nurtured roses to be shipped as far as England. Noe Pond, a mecca for families for miles around in summer, provided ice, cut during winter, for the dairy and the greenhouses. Produce fields and orchards thrived. Outbuildings were spread across the landscape. The Noe family housed workers and families on the farm. Some workers lived in small rooms in the potting sheds between the greenhouses and ate their meals at the boardinghouse atop the hill. Many hands from the surrounding countryside also came to help harvest seasonal crops. Ruth Churchill, whose mother was a Noe, wrote affectionately in her book *Memories Entwined with Roses* that the farm was "an isolated community unit—an extended family." This image shows the turn-around for carriages owned by members of the family. The horse is Cricket, the favorite of Bertha Noe, wife of Louis A. Noe.

The first member of the French Huguenot Noe family came to America in 1663. The first Noe reached Chatham Township before the American Revolution. His grandson, Louis Mulford Noe (above left), born in 1847, married a Green Village woman named Emily Brant (above right) in 1869. Their three children included Maria Meeker Noe (left), who married Lincoln Pierson in 1892. They were the parents of Ruth, who became Ruth Pierson Churchill, the township's most influential historian. Louis Noe built Noe Farm into prominence. When Chatham Township reorganized in 1899, he became the first mayor and served in that capacity until his death in 1909.

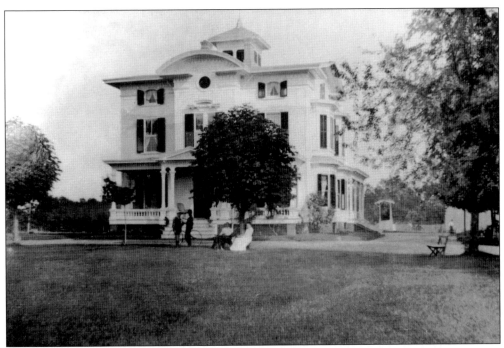

The Noes lived in imposing houses. Louis Mulford Noe enlisted the aid of a dowser to find water before starting construction of his Victorian house (above) in 1871. His son, Louis Albert Noe, later built the more traditional mansion (below). Both houses were on old Race Course Lane (now Noe Avenue).

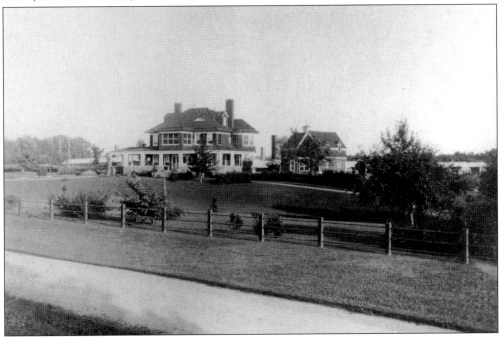

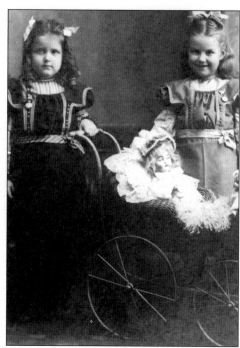

The Pierson girls—Helen, Ruth, and Edith, daughters of Lincoln Pierson and Maria Meeker Noe—were ever ready to pose. The girls are shown as follows: (above left) Helen and Ruth, 1903; (above right) Helen and Ruth, 1901; (below left) Helen, Edith, and Ruth, 1907; (below right) Helen and Ruth, 1899.

One of the treasured Pierson family pictures was this lovely portrait of the oldest daughter, Helen, who was about eight years old when the photograph was taken.

Louis A. Noe's front driveway entrance was simple and neat, as befitted a family that sought to live unpretentiously. The gardens near his house, always well maintained, also impressed visitors for their uncluttered and dignified presentations.

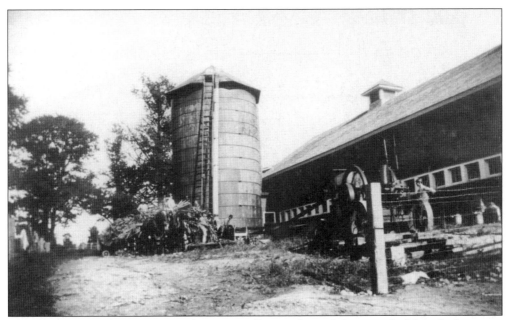

The Noes were working farmers. When cornstalks were being fed into a silo (above), the owner was beside his farm hands to ensure proper loading. He constantly inspected his clutter-free pasture (below), a basic part of the farm's extensive milk business. Noe Farm had a herd of about 350 cows, all certified by local doctors as disease-free, a very important fact in the days before pasteurization.

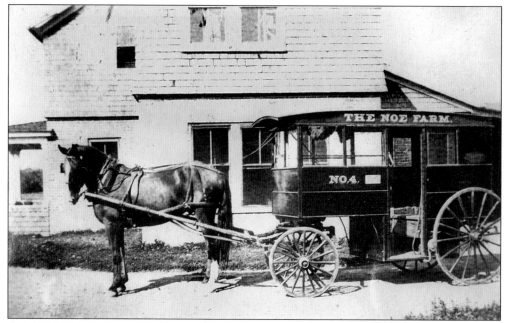

As the 19th century turned into the 20th, a familiar predawn sound throughout areas surrounding Chatham Township was the steady clop-clop of a Noe horse pulling a milk wagon (above). Even in pre-pasteurization days, Noe milk was known for its healthfulness. Briskly moving trucks replaced wagons in the 1930s, but Noe Farm continued as a symbol of quality milk. The address on the truck was Madison rather than the actual location in the township.

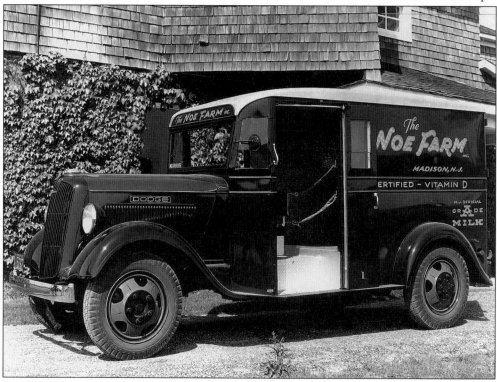

Winter ice guaranteed year-round cooling on Noe Farm. Ice on the pond was cut when it was about a foot thick. It was then pushed up the troughs into the icehouses, where sawdust was packed around the blocks to prevent melting. Ice was used for cooling and preserving milk. The greenhouses also needed ice to harden off roses in a giant icebox.

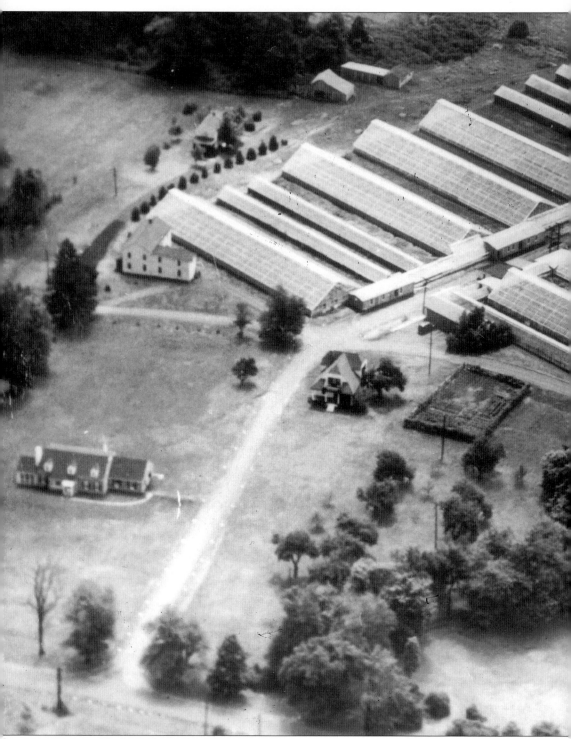

Louis Mulford Noe began building greenhouses in the 1880s, joining dozens of rose growers in the area. Roses grown in greenhouses (above) were cut and taken to the Madison or Chatham railroad station for shipment to the New York flower market. A Noe specialty was the

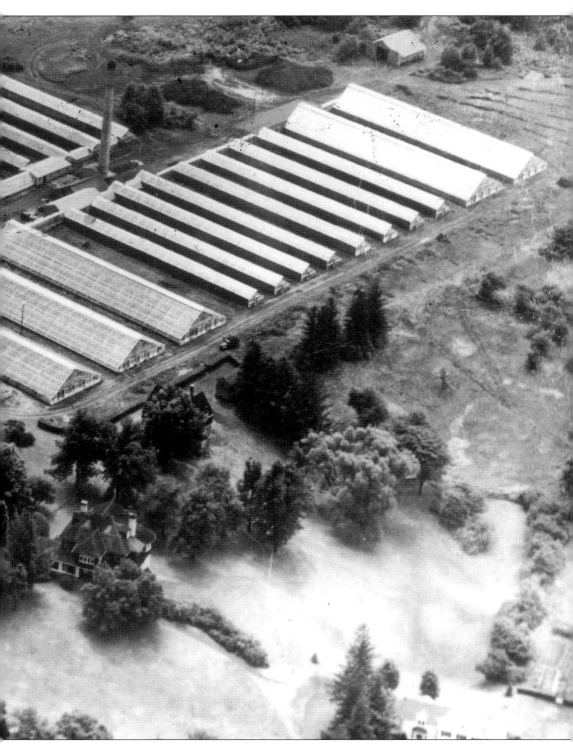

American Beauty rose. Such roses, on six-foot-long stems, were often sent to Queen Victoria at Buckingham Palace in London. The stem ends were placed in potatoes for moisture and carefully packed in moss for the long steamship voyage to England.

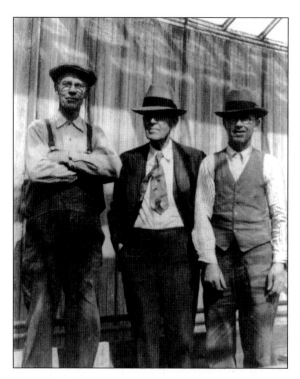

Louis Albert Noe consulted often with his greenhouse supervisors. Here he is meeting with Emmett Doty (left) and Alan Doty, superintendent of greenhouse operations. Noe's coat, shirt, and tie were not unusual for a farm owner.

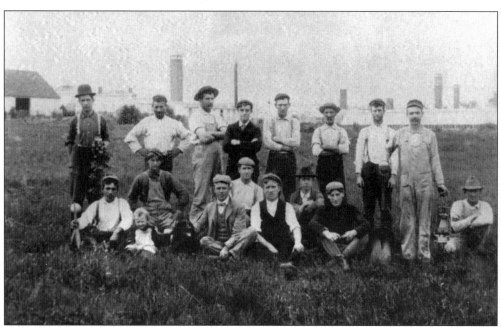

Noe greenhouse workers pose for a group portrait c. 1910. These were skilled men in fine physical condition. For all their fine appearance, roses were tough wards. Coal had to be shoveled into furnaces to heat greenhouses in winter. In late spring, glass had to be whitewashed to cut internal heat. Weeds had to be pulled year-round. A competent crew made a successful rose grower.

The heart of Noe Farm's extended family was the Neighborhood House, built on the farm by Noe carpenters to provide a social, educational, and religious center for farm workers. This photograph is of the "family" gathering for Sunday school. Many social events were held on the property, from birthday parties to holiday celebrations.

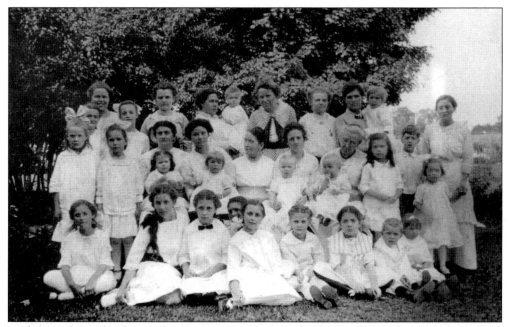

Birthdays of Noe family members were occasions to unite the family, workers, and supervisors alike. Since parties were in the afternoon, only mothers and small children could attend. This party was for the first birthday of a Noe granddaughter.

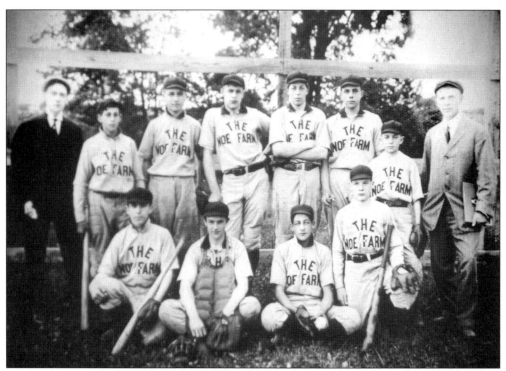

Baseball teams were common among workers on large farms. They were sponsored, in this case, by Noe Farm and wore the farm's name. They met area teams regularly. When they journeyed to play in other towns, Noe family automobiles sped them to distant fields.

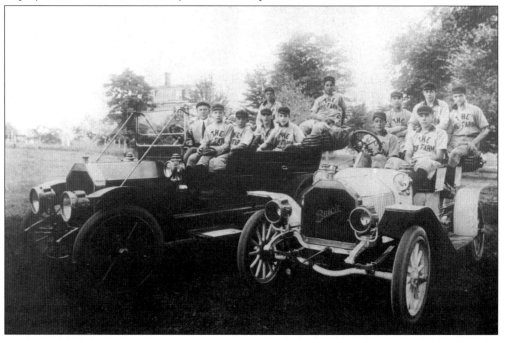

Sometimes, the celebrations were family only, such as the one shown here. The date is not known, but the occasion was a birthday party for Grandmother Noe. Only two children attended, and from the pose of the little boy in the front row, the excitement had not yet begun.

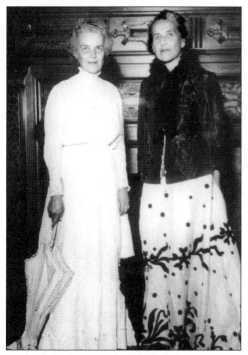 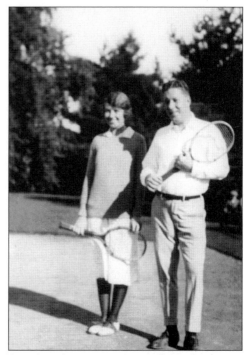

In the left photograph, Helen Pierson Brower (left) and Ruth Pierson Churchill are shown at a formal party on May 30, 1950. In the right photograph, Helen and her husband, Bailey Brower Sr., pause during sets on the family tennis court.

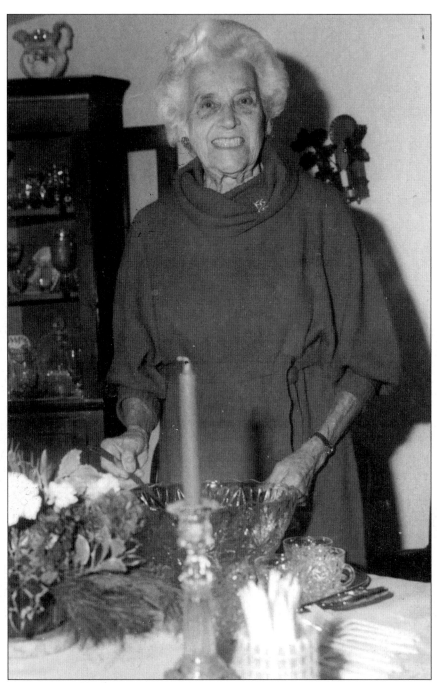

If not the most remarkable person in 20th-century Chatham Township—as likely she was—Ruth Pierson Churchill was its most charming, dedicated, and vivacious leader. Shown at a Christmas party on December 13, 1987, when she was 90 years old, Ruth died in August 1999, just a few days short of her 103rd birthday and four months shy of having lived in three centuries. Her book *Memories Entwined with Roses* is a remarkable and entertaining summation of a worthy century of living. The book remains the unofficial history of Chatham Township as it was in the 20th century.

Five

MOTHER OF FIGHTERS

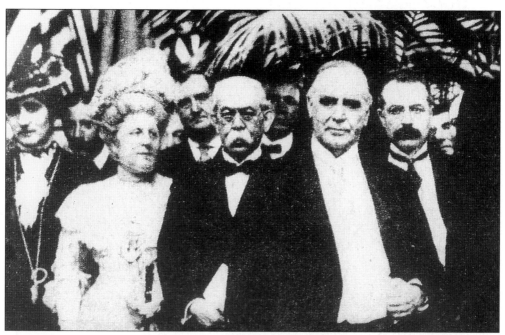

She was born in Turkey as the daughter of French and Armenian parents, was graduated from the American College in Constantinople, spoke four languages, had a well-trained soprano voice, was married to the secretary of the Turkish Empire's delegation in Washington, D.C., was a close friend of Pres. and Mrs. William McKinley, and in Chatham Township ran a nationally known training camp for prizefighters. Her name was Madame Sidky Bey, and she lived in the social world of diplomatic Washington. In 1898, in the nation's capital, she gave birth to Rustem Bey, who became Chatham Township's first police chief in 1941. Madame Bey sang "The Star-Spangled Banner" on September 5, 1901, in Buffalo, New York, at the opening of a program of the Pan-American Exposition. After hearing President McKinley give his address, she was only two people away from him when he was fatally wounded by an assassin's bullet. She is shown on the far left of this image.

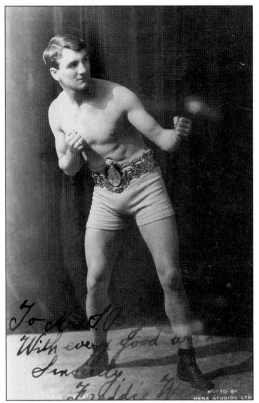

Madame Bey's prizefight story began with Freddy Welsh (left) of Wales, world lightweight boxing champion from 1914 to 1917. Nicknamed the Welsh Wizard, he came to America and invested his savings in a mansion (below) near the Fairmount-Meyersville Road intersection. There he opened a health farm for businessmen. When he joined the U.S. Army as a captain in 1920, he asked Madame Bey to continue the farm. She agreed but decided to broaden her business base by including prizefighters. She became the only woman in the United States to operate a training camp for boxers in all weight divisions. Many of the boxers chose the camp because of Madame Bey's language skills. The camp was moved to Bey's own farm at 516 River Road in the mid-1920s.

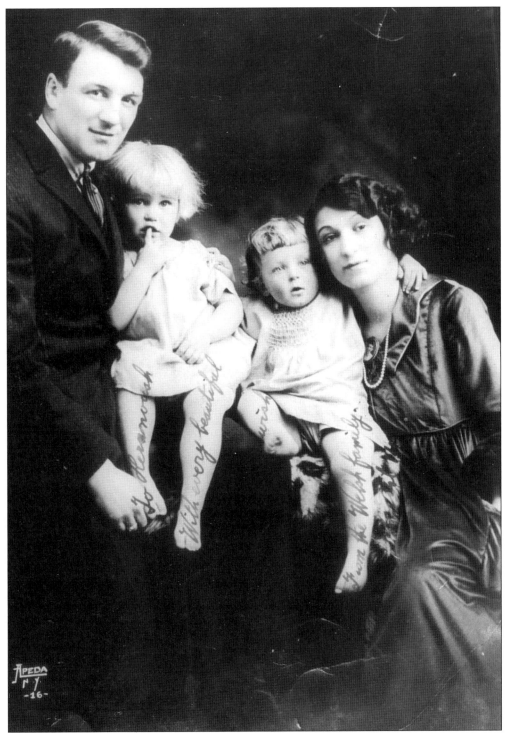

Freddie Welsh inscribed this photograph "from the Welsh family" to "Hranoush Bey," presumably Madame Bey, a friend and neighbor. Welsh's wife is on the right. Between them are Fred Jr., on his father's lap, and daughter Bette.

In this *c.* 1900 portrait, two-year-old Rustem Bey poses with his father, Sidky Bey. Rustem grew up in the social whirl and diplomatic pace of Washington, D.C. He spoke three languages fluently before he was 10 years old.

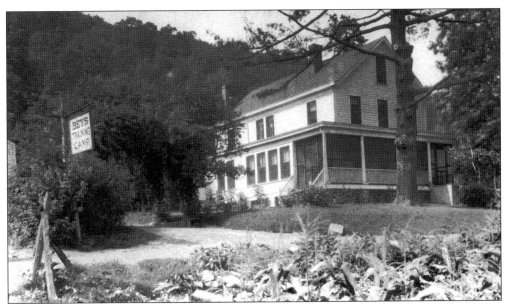

Madame Bey transferred her prizefighters to this modest farmhouse on River Road *c.* 1926, just as the golden age of boxing was beginning. She built a full-sized ring adjacent to the house, and there fighters staged boxing exhibitions daily. To please a visiting newspaper photographer, 10 of her fighters-in-residence and their trainers pose in front of the Training Today sign beside the camp driveway.

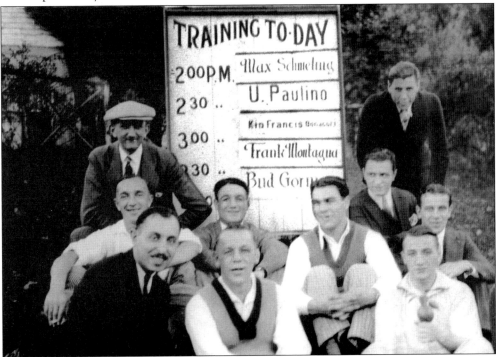

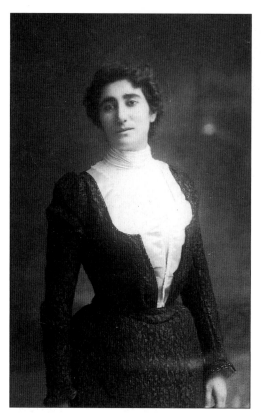

Even during her many years with the prizefighters, Madame Bey always remembered the fast-paced days in Washington, D.C., when she was a handsome young woman (left) with a gift for languages and an exciting singing voice. She fondly recalled the years in Washington as a young mother (below), whose bright son inherited her language abilities.

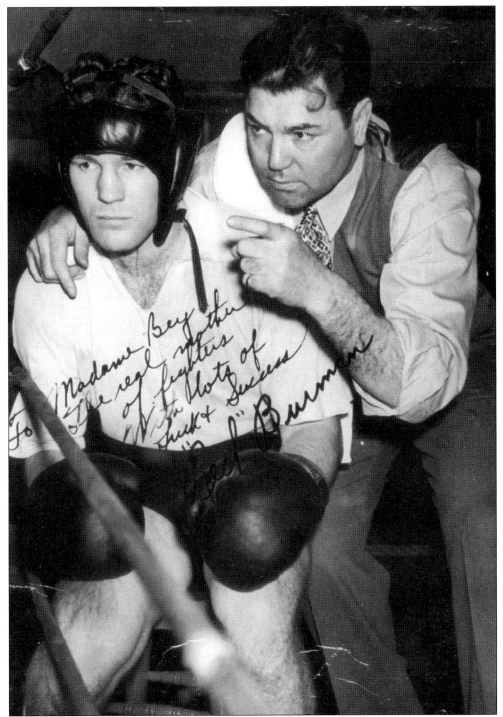

Red Burman, who fought Joe Louis in 1941 and lost (as did all of Joe's opponents when he reigned supreme), left a lasting tribute to the first lady of the camp. His inscription on this photograph was dear to her heart: "Madame Bey, the real mother of fighters, with lots of luck and success."

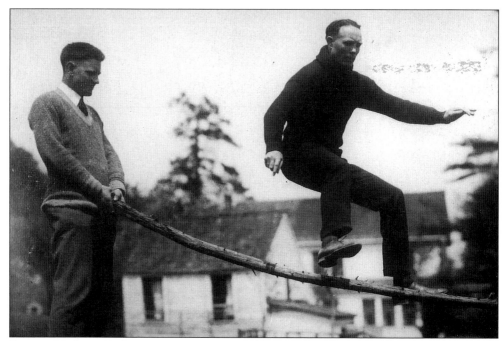

Days at Madame Bey's training camp were arduous. Fighters ran long distances along River Road and Fairmount Avenue, jumped rope or over a stationary limb (above), punched the bag, and sparred in the ring. At night, however, the place took on the air of a happy family (below), with parties and card games, usually much more ordered than this slapstick fumbling. Madame Bey's granddaughter Bette Anne Bey (on the right) often enjoyed watching the capers.

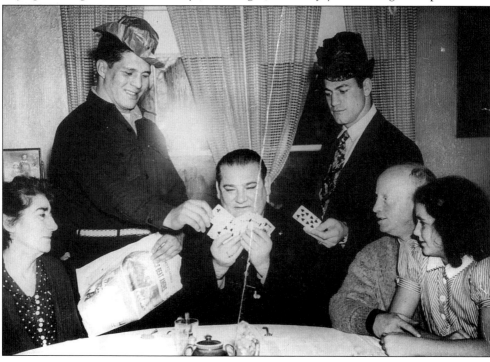

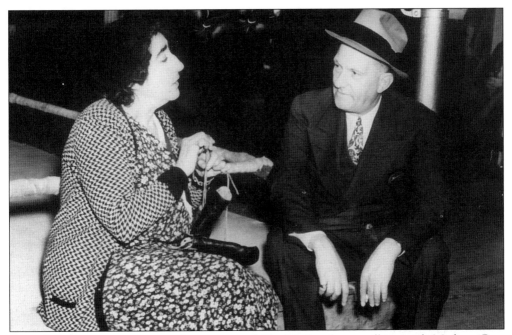

One of the frequent visitors at the camp was Mike Jacobs, shown talking with Madame Bey. Jacobs was one of world's best-known fighter managers. His most famous client was Joe Louis, unquestionably one of the greatest heavyweights of all times.

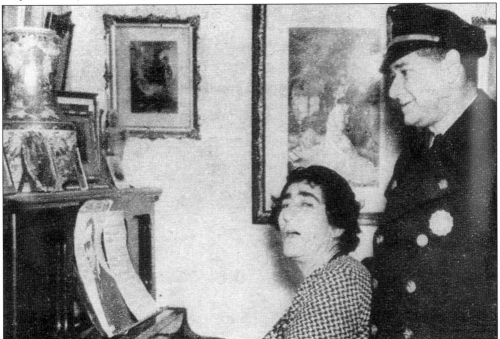

Bey planned the schedules, ordered the meals, and arranged the fun evenings. On one social occasion, she showed off her fine voice, with her son Rustem Bey (Chatham Township police chief) providing harmony. Rustem Bey was the township's first and, from 1941 to 1953, the township's only police officer.

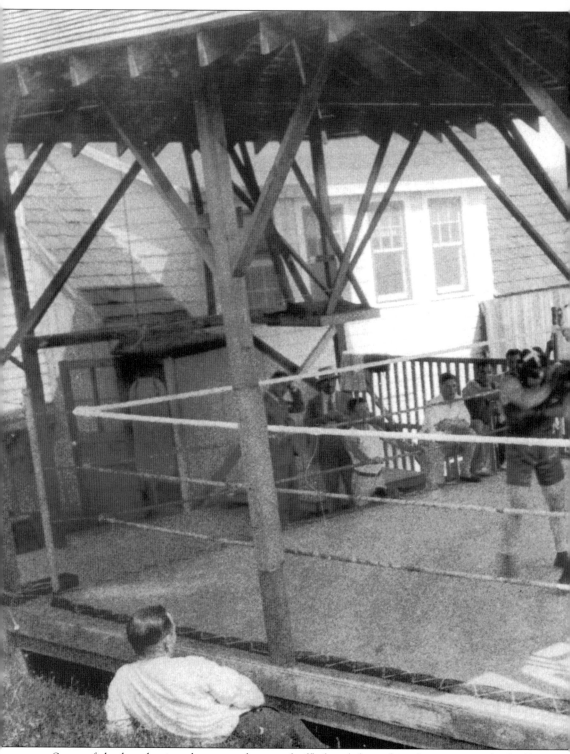

Some of the best boxing shoes ever known shuffled and danced in this ring outside the Bey home and fighter dormitory. Referees controlled the action as fighters from every weight

classification punched and counterpunched. Boxers wore oversized gloves to cut down on possible damage to a fighting face. Few weeks passed without a world champion in camp.

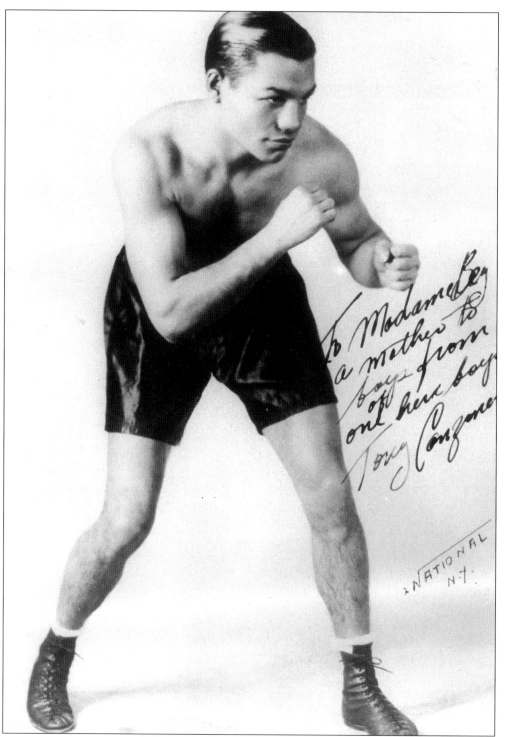

Tony Canzoneri, lightweight champion of the world from 1930 to 1933, had no hesitancy in expressing his appreciation for the camp and its owner: "To Madame Bey, a mother to boys from one of her boys, Tony Canzoneri."

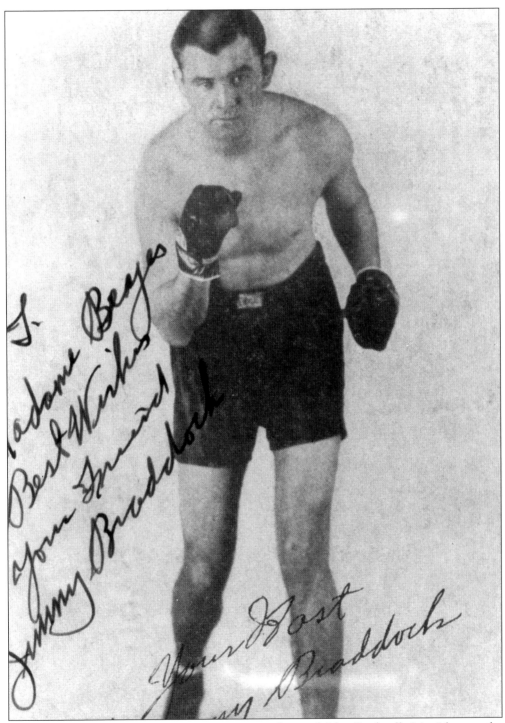

Jimmy Braddock, of Bayonne, New Jersey, was nicknamed "the Cinderella Man" because he won the world's heavyweight title by upsetting champion Max Baer in a 15-round slugfest on June 13, 1935. He autographed his picture but proved to be a better boxer than speller by calling his host Madam Beyes.

Jack Dempsey, "the Manassa Mauler," one of the nation's great heavyweights, trained under Bey between 1919 and 1926, when Madame Bey operated Freddie Welsh's Health Farm. Dempsey won the world title on July 4, 1919, by knocking out Jess Willard in three rounds. He held the title until 1928, when Gene Tunney out-pointed him in 10 rounds.

Six
WAYS TO GO

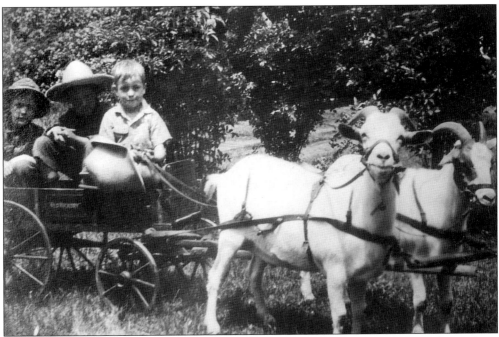

Chatham Township always has needed a way to get somewhere else, mainly to Madison, about two miles to the north, or Chatham Borough, about a mile away. There, since the earliest settlement, were the needed churches, stores, people, and (after 1837) the railroad that could take them into a distant world. Incidentally, before laying the tracks through Madison, the railroad builders had flirted with the idea of building the railroad through what is now Hickory Tree. It was not to be. How different life would have been in the township is idle conjecture.

In the beginning, residents walked to Madison or Chatham; many workers from those towns walked to Noe Farm jobs until deep into the 20th century. Township residents found many ways to travel, including the goat cart shown here. True, it only carried the Diefenthaler children around the neighborhood, but for them it was the way to go.

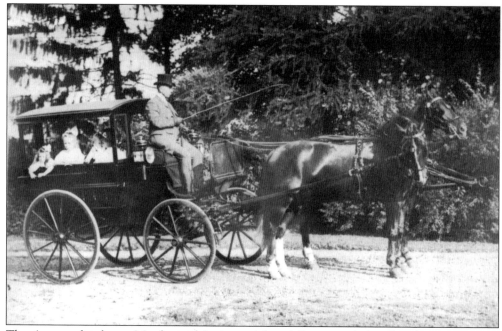

The Averett daughters, Martha and Janie, and friend Erna traveled in handsome equipages when these photographs were taken *c.* 1915. The way was quite formal in the photograph above, even to the top-hatted driver. Informality ruled the day below when the family set out for an afternoon's drive in an open, two-seated surrey.

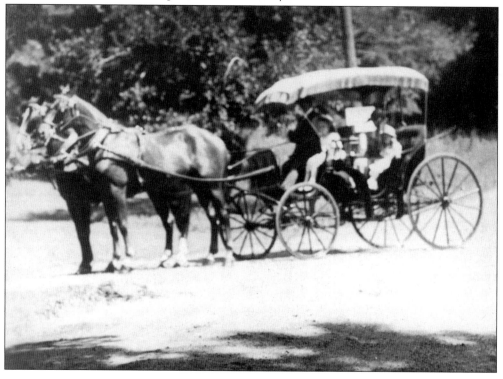

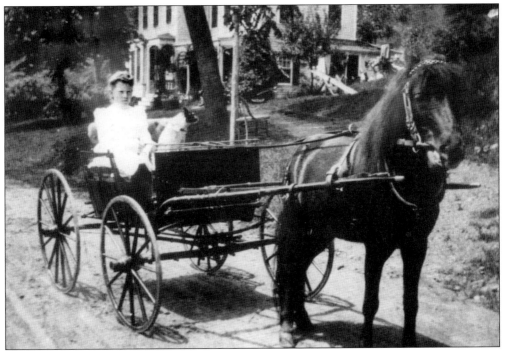

Clara Baldwin was a familiar sight on River Road and adjacent streets in the 1920s, when she drove her pony cart by herself. She was the daughter of Dayton Baldwin, a dealer in horses whose home and farm were at 360 River Road.

Dual horses, with a low-slung buggy behind, were a common sight near the Fuller estate on the corner of the Shunpike and Noe Avenue. Roads were wide open, and daring young riders often raced at top speeds across the dusty, unpaved surfaces.

The Diefenthaler children became experienced in driving horses on roads surrounding their farm at 122 Southern Boulevard. Even the youngest could handle the reins of the one horse

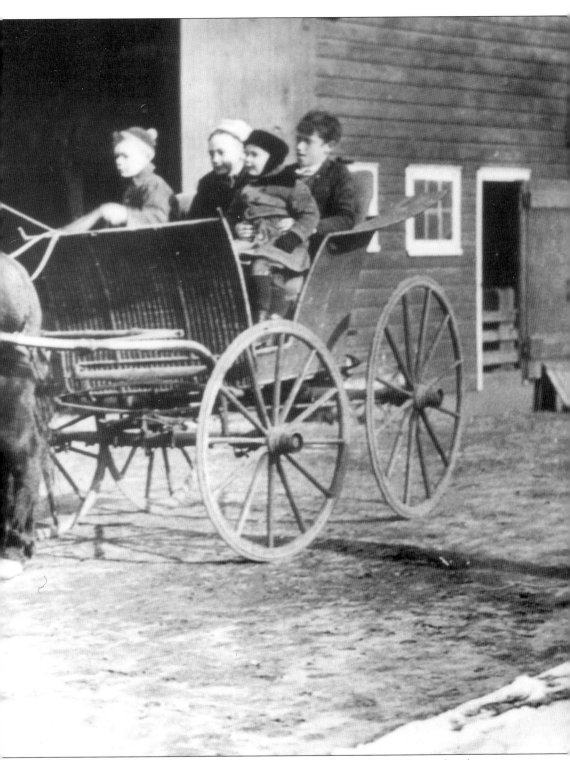

that pulled their workaday buggy. Left in the barnyard on this particular day is a handsome pet, whose pose indicates he was disappointed that the children would set off without him.

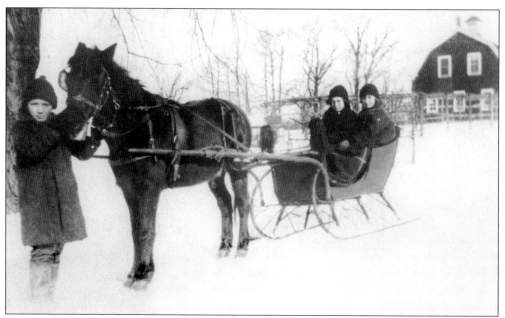

Whether in winter, when snow blanketed the roads, or in summer, when dust swirled off the dirt roads, the Diefenthalers were on the move. They sped to school or to social occasions in a one-horse, open sleigh (above). Nothing delighted the family more than when Dad and his team easily pulled away from an early automobile chugging along Chatham Township byways (below).

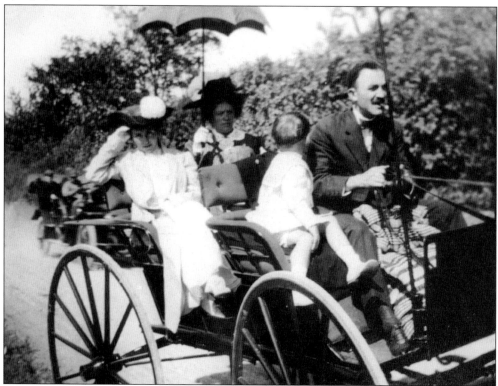

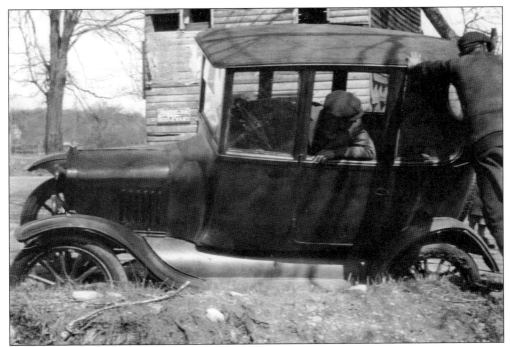

The shiny, almost-new Ford, mired in mud, amply deserved the commonly used gibe, "Get a horse!" In this case, it proved to be undeniably true: a horse had to be summoned to do what the car and the men could not possibly accomplish.

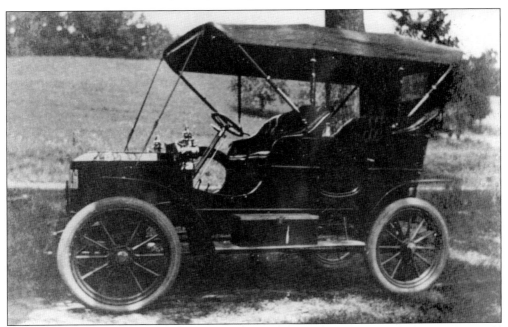

One of the region's first cars was this 1908 Stanley Steamer touring car. The canvas top could be easily folded down, which made for a considerably uncomfortable ride without a windshield to fend off dust. Women and men both wore dusters over their clothing in an effort to arrive at a destination looking stylish, if not totally dust-free.

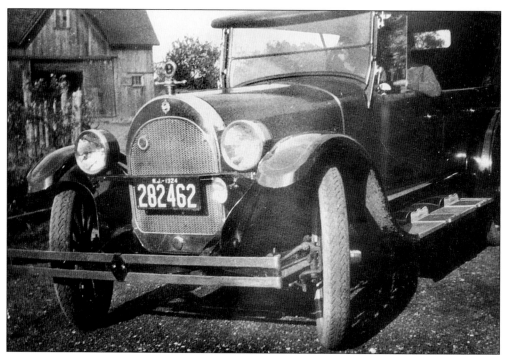

The Knapp family, of 158 Southern Boulevard, had at least two cars in 1924. The touring car (above) was used if the family was to be along. The sport roadster (below) gave the younger family members a chance to show off a bit. With the top down and a spare tire in the running board, a sunny afternoon offered great fun. The dog on the running board missed the action.

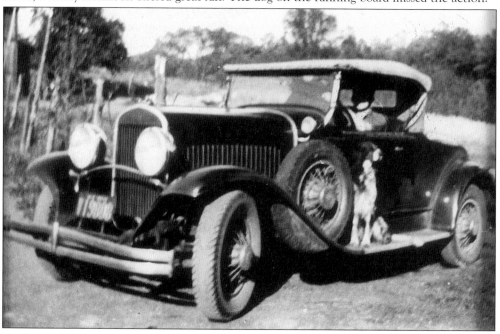

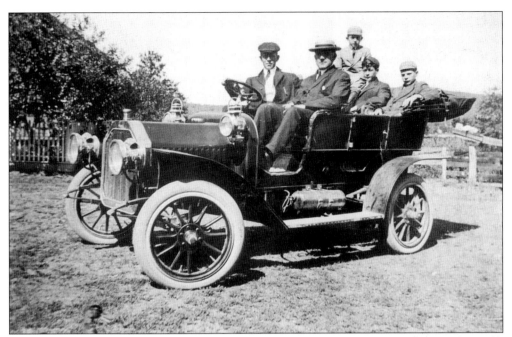

When Louis A. Noe and his son-in-law Lincoln Pierson set off on a fishing trip in this well-equipped touring car, they took along three members of the farm's baseball team. The car was likely headed for Shongum Lake near Morris Plains for bass fishing or to the well-known Musconetcong River near Hackettstown where trout abounded.

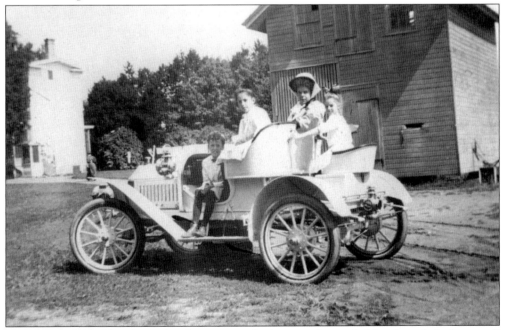

Back home, Mrs. Noe (considered a pioneer for her time) traveled local roads in her small Buick roadster. She needed to shop in nearby Madison or Morristown or to transport her children to the various after-school activities and lessons that were necessary for children of well-to-do parents.

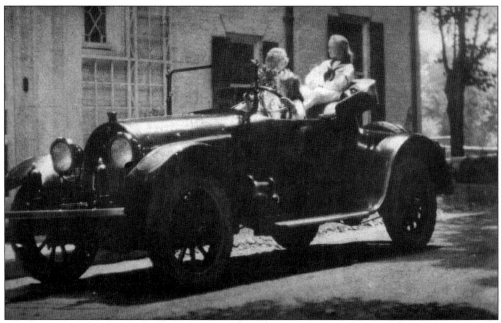

The Averetts of Dixiedale Farms on Hillside Avenue were partial to roadsters. The single-seat open car (above) was the 1919 mode of joyous travel. Later, in the 1930s, it was still roadster time. The classic roadster (below) parked in front of the handsome Dixiedale house had all the appearance of a car advertisement in an exclusive magazine.

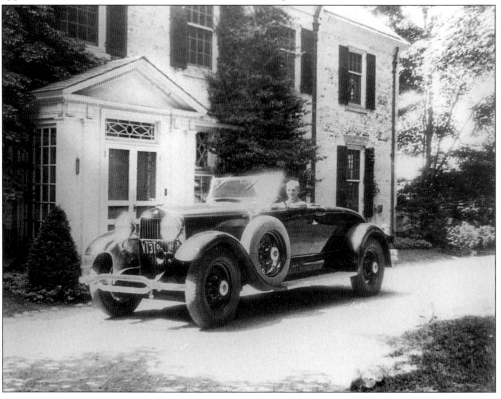

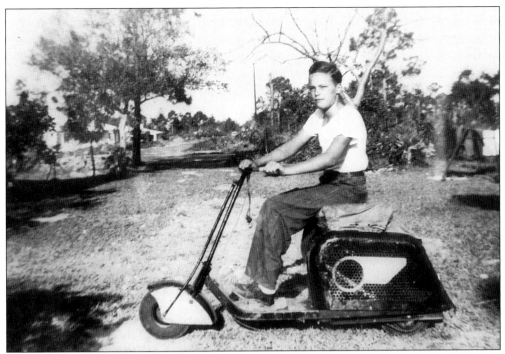

By the 1960s, youth was being served by two-wheeled cycles. These ranged from the utilitarian scooter (above), which was at least better than walking, to the kind of powerful motorcycle (below) that Marlon Brando or Jimmy Dean might have tooled around Hollywood's streets and into movie scenes.

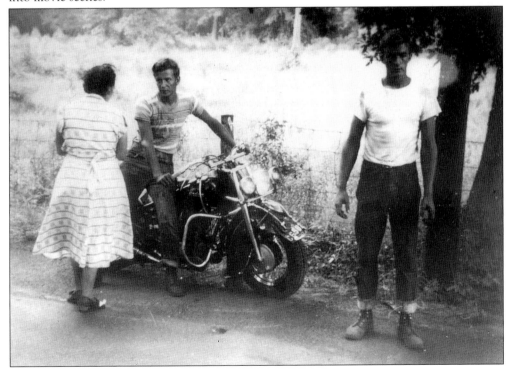

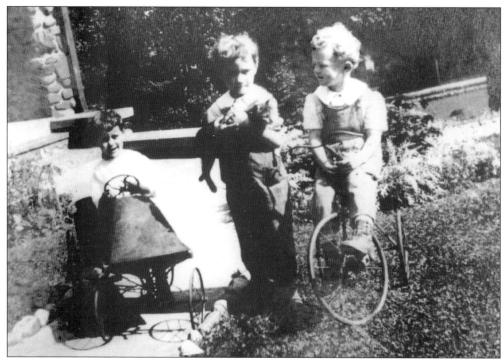

No matter what their ages or their time in history, the Diefenthalers had a fondness for wheels. They could choose between a small child's automobile or a tricycle (above). If they could not buy a vehicle, they made their own (below). The body has a forewarning of the 21st century, when advertising became emblazoned on almost anything that moved.

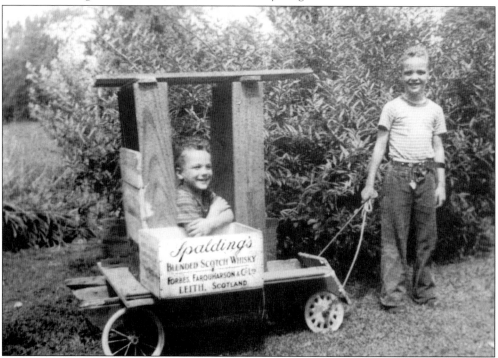

Seven

A COMMUNAL EXPERIENCE

Shortly after World War I, a small group of Jewish immigrants living in New York City dreamed of an experiment in communal living. They hoped to get back to nature living outside of the city and were eager to obtain better education for their children. Most wanted to continue working in New York and needed a railroad to carry them into the city. In 1922, they chose about 100 heavily wooded acres in the Floral Hill section of Chatham Township, close to the Chatham Borough line and running north along Lafayette Avenue to just beyond Southern Boulevard. They divided the property by lot, as could be expected in an idealistic colony. Most members were highly educated, but the group included all walks of life: teachers, artists, newspaper editors, a real estate broker, several tailors, a movie producer, a printer, and a few musicians. Some descendants of the founders still live there, but nearly all original houses have been much remodeled or replaced. Louis Thorner (right), one of the founders of the Colony Association, bought two acres in 1922. He was a tailor by trade but planted an orchard and raised vegetables and fruit for sale at his property.

This is the simple house that Louis Thorner built. The vegetables and fruit that he produced in his small orchard and large garden were sold from a stand in front of his property. His daughter, Blanche Thorner Blumenfeld, tore down the small original house and built a new home at the site, 12 Maple Street.

The association set aside five acres of land at the corner of School Avenue and Spring Street for a school and social center. The school was never built, but the social center has survived as Colony Pool. Nearly all children attended classes in the Red Brick School until 1929, when Southern Boulevard School was opened. Bernard Sommer bought the three-story mansion above, at 269 Lafayette Avenue, and conducted a private school there until the Great Depression ended his venture. In local lore, the school became known as the Big Mistake.

The Thorner farm, on Maple Street, became well known. Louis Thorner (above left) is shown inspecting his gardens with his daughter Blanche and a neighbor, Mr. Schwartz. Blanche (above right) is shown feeding the family's white leghorn chickens in the coop near the garden. The leghorns, known as prolific layers, are in the photograph below.

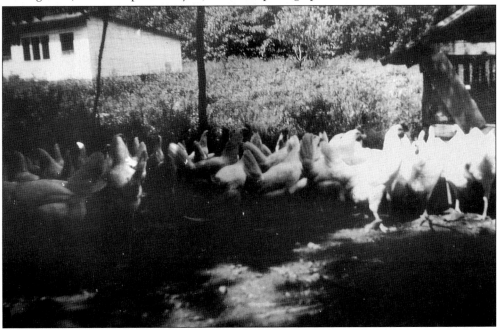

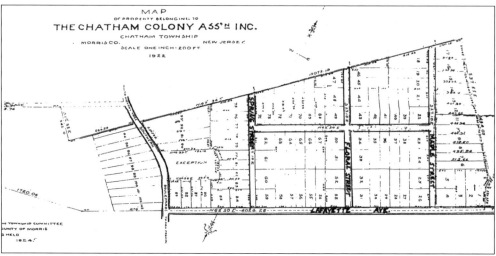

A map drawn in 1922 shows the setting and size of the Chatham Colony Association. The property keyed on Southern Boulevard and Lafayette Avenue, although 10 two-acre plots were on the west side of the boulevard. In all, there were 193 two-acre properties. The modern thoroughfare closest to the Chatham Borough line is Maple Street, opposite Chatham Township High School. Each lot cost $200 in 1922, regardless of the quality or location of the land.

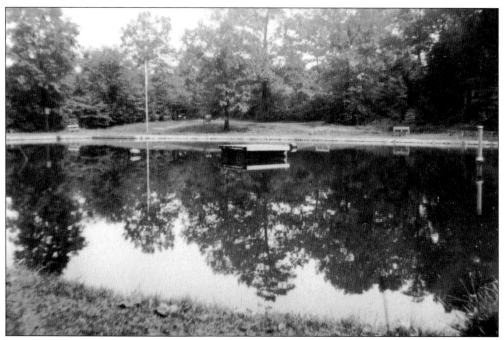

The Colony Pool at the corner of Spring Street and School Avenue was gradually formed from a natural spring on property set aside for the proposed school. Old-timers recall that "children loved to play in it even when it was only a mud hole." Residents drained the swamp and gradually formed a large, clean pond for swimming and fishing.

From left to right are Gabe Katz, Billy Weisgerber, Herman Nauman, and Bert Abbazia on the diving board at the Colony Pool in the days when the pool was new and they were young.

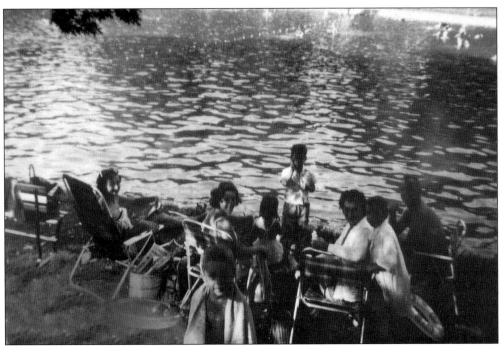

In summertime, the living was easy at the pool. Grandmothers, mothers, and younger wives gathered in lounging chairs near the edge of the pool and talked about things immemorial—children, grandchildren, food, the theater and opera, and the future. In the photograph below (c. 1934), Jackie Gibson pushes while Robert Brindle, Bert Abbazia, and Milton Abbazia fill to capacity what looks like a homemade boat.

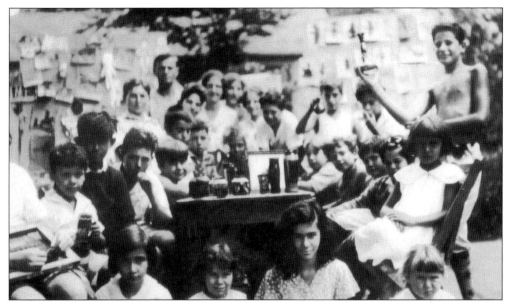

For many boys and girls, parts of every July and August became serious at summer camp. Counselors guided children through swimming lessons, boating experiences, and conducted classes in Hebrew culture and art. In the background, the large board is filled with the Hebrew alphabet and examples of children's summer artwork.

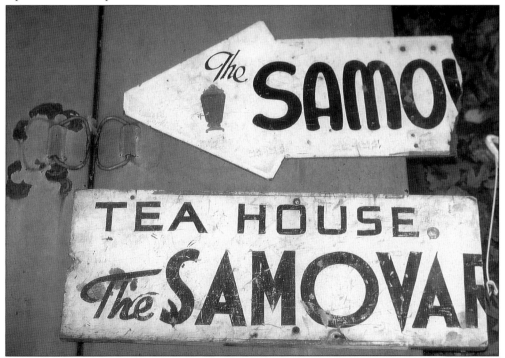

The colony and its neighbors came together most easily in the Samovar Tea House, opened on Floral Street in 1936 by Eda Koukly. It offered Russian-American cuisine and pastries baked on the premises. Signs on Lafayette Avenue pointed the way to the unique restaurant. The Samovar closed in 1942 due to World War II rationing.

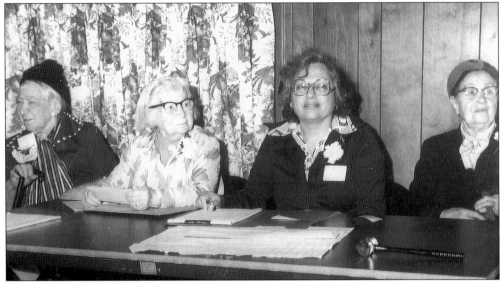

On May 26, 1986, the Chatham Township Historical Society hosted a panel to discuss the colony's history. Shown from left to right, panelists Florence Robbins Stea, Goldie Chibka, Esther Thorner Hirshfield, and Jennie Switzen talked of the pleasant surprise early colonists had when surrounding neighbors were friendly. They talked of education, the pond, the Samovar Tea House, the sales of lots, and many other things that formed a lasting colony in the township.

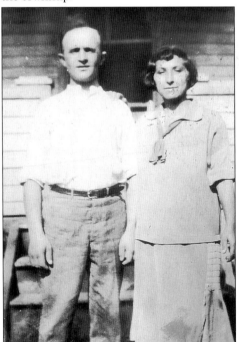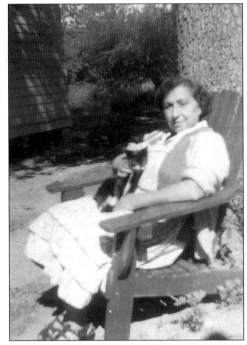

When Louis Thorner's wife, Clara Morrison Thorner, refused to live in a tent, he came out from New York on weekends and built a two-room house. They later added two rooms and a porch on ground level and, as the years passed, built upstairs rooms and an interior stairway. Finally, Clara was able to relax in a deck chair with her cat, leading a simpler, easier life.

Eight
WORK AND PLAY

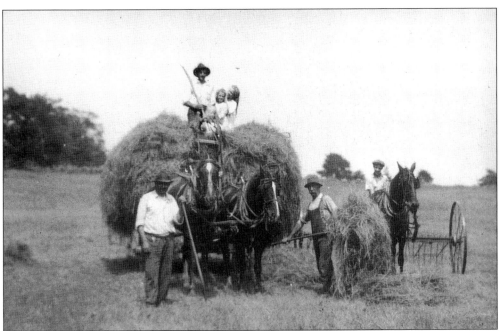

Life on a farm meant long hours and unrelenting toil, around the clock, around the year, but there was time for fun as well. A fine example of combining work and play is shown in this picture, snapped in the Averett family hayfields in 1917. The two little girls on the load of hay (probably Averett children) were boosted aboard by farm hands. They enjoyed the excitement of seeing hay pile up around them, followed by a leisurely ride to the mow in the barn where the hay was stored.

Similarly, children looked forward to riding on the backs of the big workhorses when a day's plowing or mowing was finished, refreshing sips after warm cow milk had been cooled, and standing in the barn while the animals were being fed. They knew that their parents worked hard—from sunrise to sunset in season—but they also enjoyed the warmth of having their parents nearby, willing to teach them that life on a farm had its rewards of warmth and pleasure.

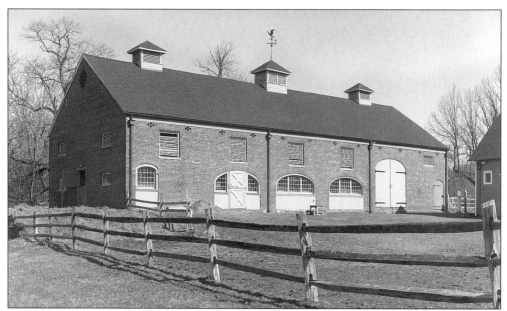

The earliest well-documented instance of combining work and play in Chatham Township came in the 1830s, when William Gibbons, wealthy owner of the Madison estate (where Drew University was founded in 1867), built this barn on Loantaka Road for many of his large string of horses. He grazed his steeds in widespread pastures and trained them on his racetrack built at the intersection of the Shunpike and Race Course Lane (now Noe Avenue).

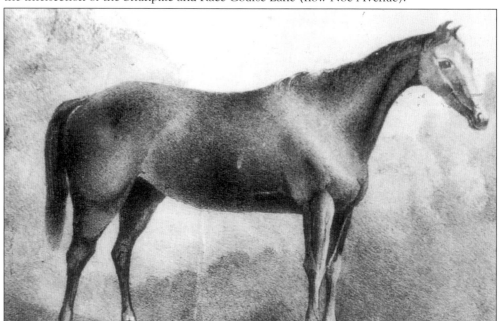

Fashion—said to be the greatest American mare ever foaled—was born on April 26, 1837, in Gibbons's stable; however, it is not known whether she was born in Gibbons's stable in Madison or his building in Chatham Township. Nine years of racing earned her the title Queen of the American Turf. One of her great victories was over the supposedly unbeatable horse Boston in a match race before 70,000 spectators in 1842.

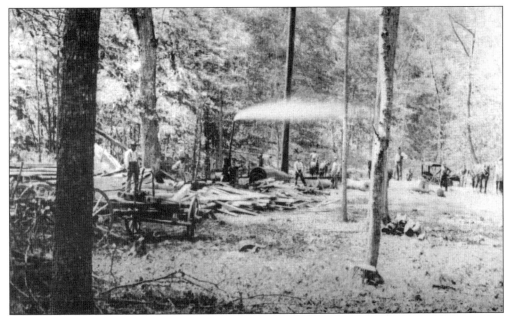

Daniel Pierson's sawmill on Southern Boulevard, where the Fairmount Commons office buildings are now located, was a steam-operated saw operated under a pole shed (poles holding up a tin roof). Pierson sawed timber felled by new residents in the Colony Association into lumber for their houses. He also supplied lumber for other township groups.

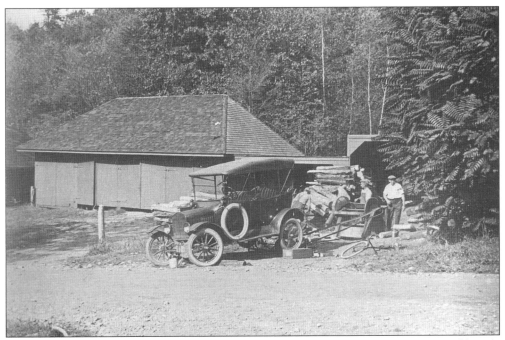

This sawmill cutting lumber on the Averett farm c. 1920 won popularity because it could easily be moved from one site to another. Power came from the engine of a jacked-up Ford. The rear axle was elevated and a wheel removed and replaced by a large wheel with a pulley rim. From there it was a matter of running a belt to the portable sawing equipment.

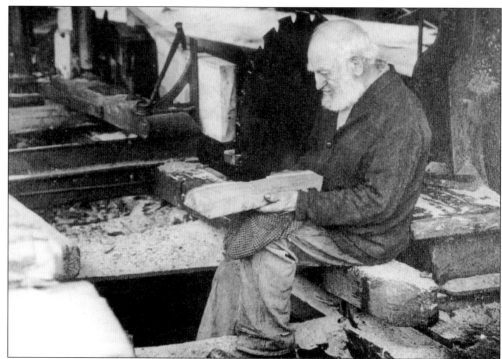

After starting a sawmill in Chester, Daniel Pierson transferred his operation to Chatham Township c. 1890. When he paused for this photograph, he was 90 years old and still vibrantly running his mill. He preferred to work by himself and only hired help when business was very heavy. He told a reporter on his 90th birthday that sawing logs, not drinking or smoking, and going to bed early were his rules for a long life.

On May 6, 1935, four generations of the Pierson family gathered to mark Daniel's 90th birthday and also celebrated the 60th birthday of Joseph Pierson, who was born on his father's birthday. Daniel told his family and reporters, "I am content and should I have my life to live over again, I would not have it any different." After the party, he returned to his mill.

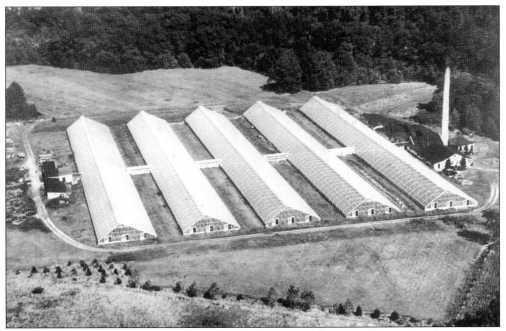

Louis Heyl started his greenhouse business in 1929, just as the Great Depression deepened. By the summer of 1947, some township enterprises—such as the Watchung Rose Corporation on the Shunpike—had grown to five large greenhouses. It was a time when dozens of prosperous businesses were devoted entirely to roses.

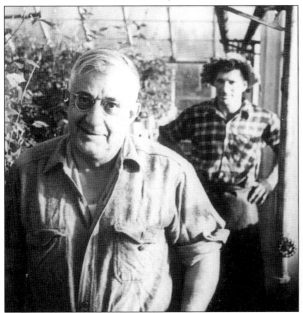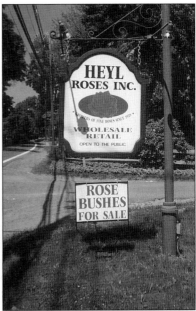

In the left photograph, the first two generations of Heyls—Louis (left) and Arthur Sr.—pose in one of the company's greenhouses sometime in the 1940s. After Louis and Arthur Sr., two more generations of Heyls continued growing roses. When the business closed in 1999, it was the last major rose corporation in the area to close. The simple sign in the right photograph told passersby for many years that roses were available wholesale and retail.

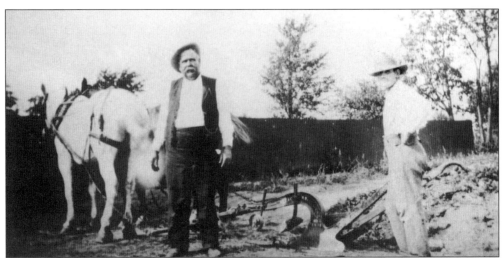

Although Louis M. Noe (left) owned the largest farm in Chatham Township and was mayor of the community, he constantly traveled across his fields and pastures to check equipment, note progress, and find any problems before they grew into major proportions. On an early spring morning, he works with a farmhand who is plowing one of the vegetable gardens.

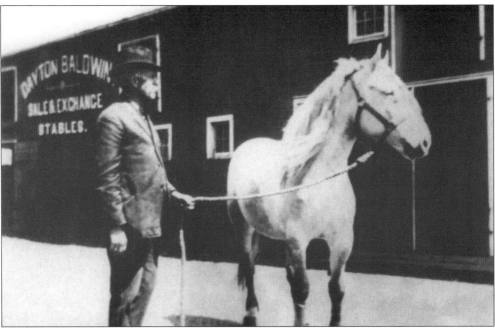

Nothing was more important to farmers than their horses. Understanding that, Dayton M. Baldwin opened a large enterprise on River Road to ensure that a supply of horses was available. The sign printed in large letters on the side of his large barn told the story: Sale and Exchange. He sold horses to you or for you, and if a farmer had a workhorse that he wished to replace, Baldwin would consider a trade.

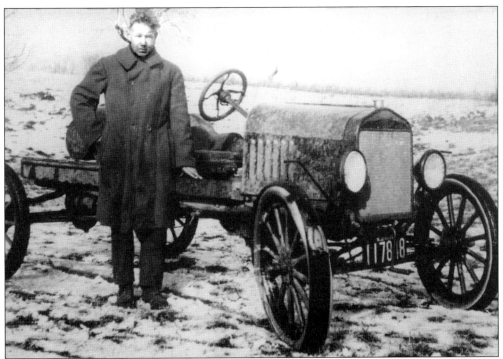

Fred G. Knapp stripped down an old automobile, leaving little more than the engine, the chassis, and four rubber-tired wheels. He used it as a tractor, and although the car had a valid license plate, the uncomfortable driver's seat and the slick tires made it an untrustworthy vehicle for area roads.

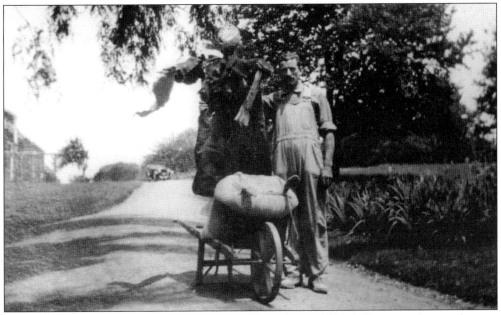

Children loved to visit the Diefenthaler farm, where they could ride horses, pick sweet berries, and enjoy the laughs that grandparents and farm hands provided, such as this scarecrow mounted on a wheelbarrow, presumably around Halloween.

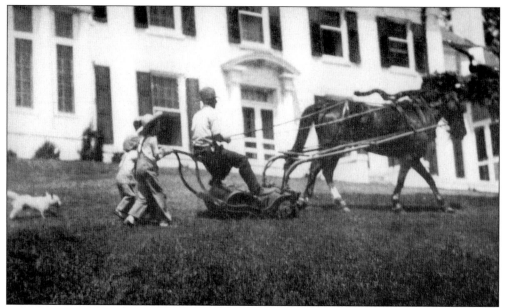

One of the earliest known power mowers, with blades turned by an ingenious system of belts, speeded up mowing the extensive lawns at Averett's Dixiedale farm. Mindless of the dangers of following a large mowing machine, the Averett children often followed close behind.

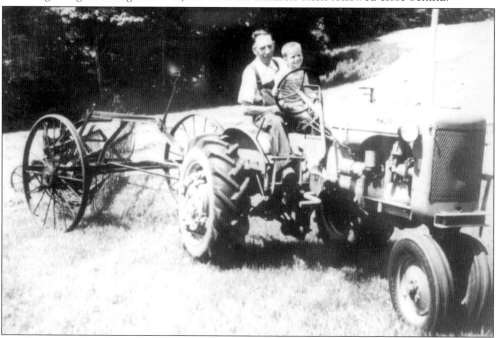

George Schwartz Sr., shown on a tractor with his grandson George Leo Schwartz, started the family's extensive dairy business in 1935. His company built numerous buildings beside Southern Boulevard, including a creamery for processing milk and milk products. Schwartz bought dairy cattle and fostered extensive herds. At its peak, the company had eight retail routes serving homes within a wide area. Selling and delivering milk door-to-door was a highly competitive undertaking that persisted until the late 1950s.

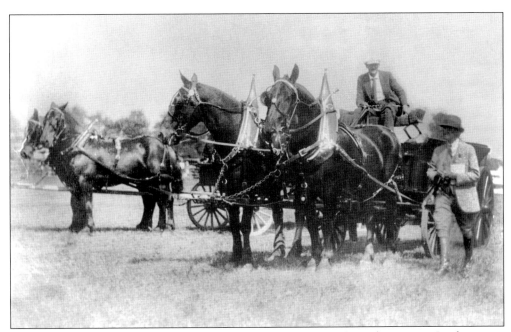

Horsepower differentiated and marked farm owners in the early 20th century. In the image above, visitors Herbert Wilson (seated) and Seth Thomas, the clockmaker, watch the powerful workhorses on Noe Farm. In the photograph below, emphasis is on the speed and intelligence of these Dixiedale steeds, who are ready to take riders on exhilarating rides across the fields.

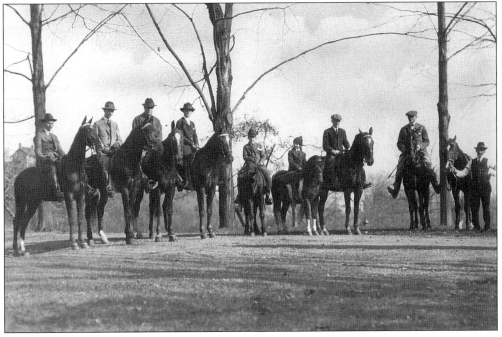

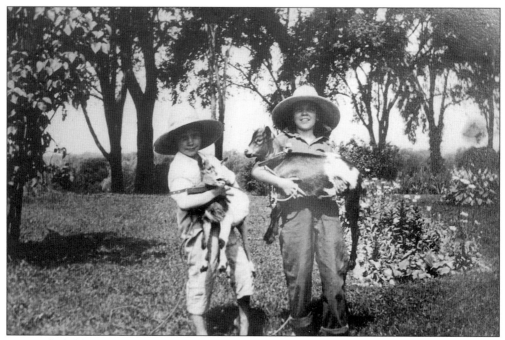

Fun and children seemed to be synonyms on the small Diefenthaler farm. In these two photographs taken on the farm, each child is shown wearing a wide-brimmed straw hat for protection against the summer sun. The two children (above) spent considerable time petting and grooming goat kids. The Diefenthaler children and their friends (below) romped in the newly mown hay.

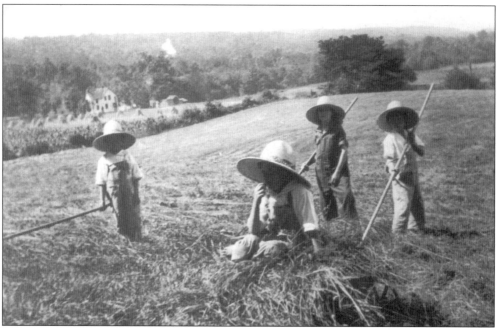

There seldom was discussion about the large numbers of kittens born on Chatham Township farms. They were always available for petting, and those who survived to become cats earned their livings chasing mice and other predators in or near the barns.

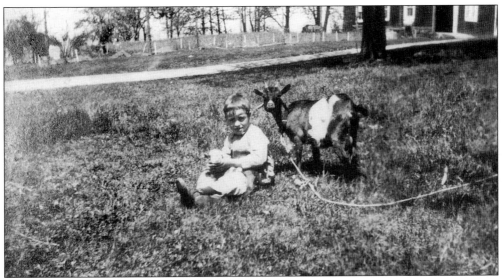

Boys and girls were not afraid of animals, and vice versa. Children often saw them born, and as they grew up, the animals became pets—whether they were baby chicks or goat kids, puppies or kittens, domestic rabbits or spindly legged foals. Occasionally hearts were wrenched when a favorite rooster or rabbit showed up on the dinner table.

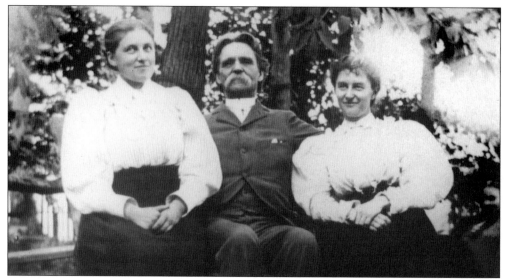

Brightness and gaiety came to Chatham Township in 1881 when Dr. Frank Fuller and his wife purchased the 70-acre Chemmiwink estate from Alice Fletcher, who had bestowed the Native American name. The property encompassed land along Woodland Road, Noe Avenue, and the Shunpike. The Fullers had extensive New York social links and entertained many noted people at the estate, most notably Mark Twain. The family spent summers at the township property and then returned to the city for the winter months. Dr. Fuller poses here with two guests, Kate Wendell and Caroline Davidson.

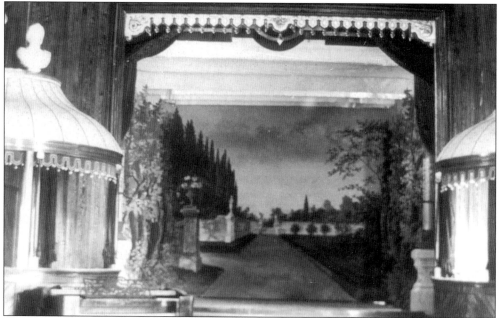

The most noted Fuller building was Holiday Hall, a former toolshed that had been enlarged and converted into a small theater. The interior was brightly decorated, and the stage, with its colorful backdrop, was installed. Between 1899 and 1902, local talent acted in plays, in which several members of the Fuller family had roles. Even the family butler was on stage, hopefully in a mystery play.

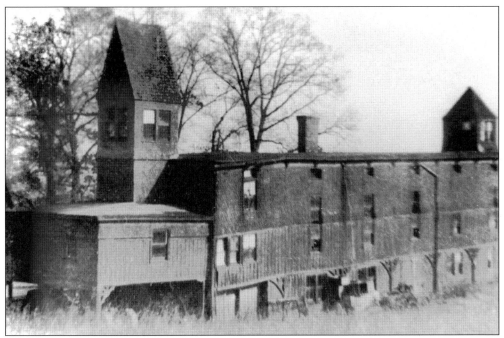

The exterior of large, sprawling Holiday Hall shows how extensive the alterations were on the toolshed. The Fullers provided ample parking space for the buggies and carriages of area guests who came to the theater. Inside, there were dressing rooms and other facilities for the actors and spectators.

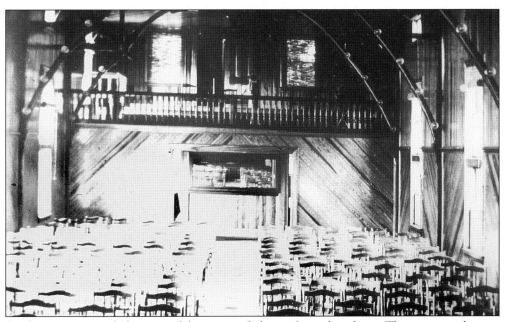

Inside, visitors were led to one of the scores of identical wooden chairs. There was no slope to the floor; seats in the rear had limited vision. The removable chairs and the high ceiling suggest that when chairs were stacked away, the building might be used for interior games.

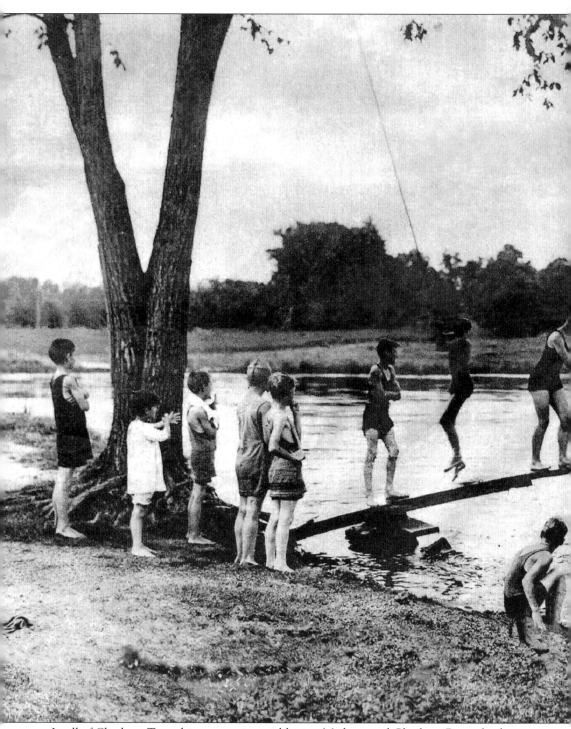

In all of Chatham Township or even in neighboring Madison and Chatham Borough, there was no attraction as popular as Noe Pond on Southern Boulevard. The Noe family permitted visitors to swim in the pond during the summer but insisted that they get written permission. These were checked at the pond each day. This picture was taken in the 1920s by the famous photographer

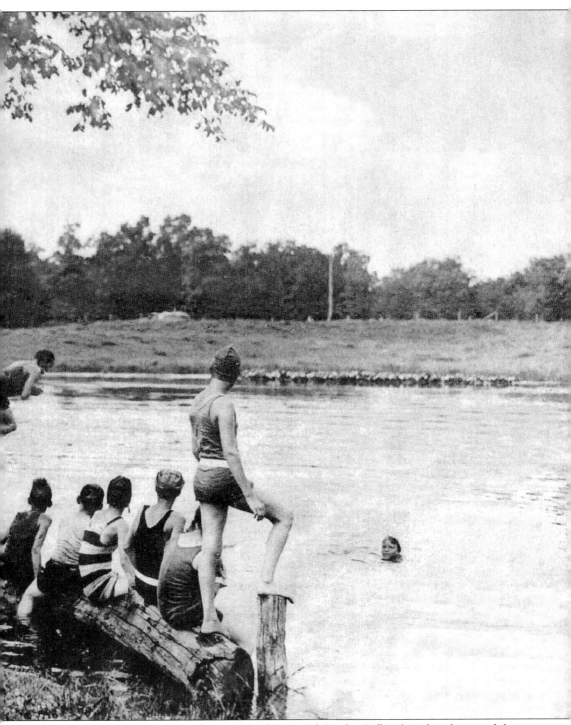

Harry C. Dorer, who came out to the pond for the *Newark Sunday Call* and produced a spread that covered the entire front page of the paper's rotogravure section. This panoramic view was likely taken on a weekday; on Sundays, there was little space for either sunbathing or swimming. The primary purpose of the pond was to provide ice during the winter.

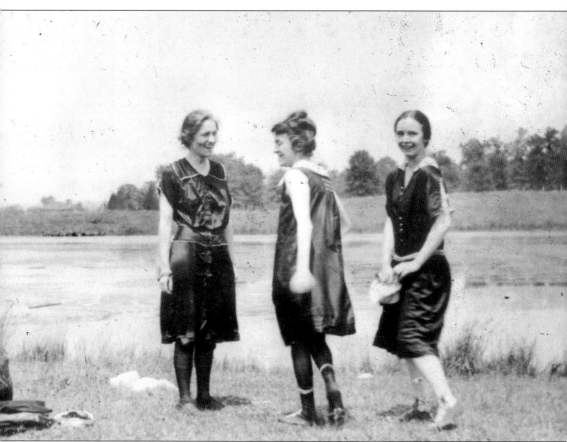

Three of Chatham Township's noted beautiful girls shyly pose for this photograph, which was featured in the *Newark Sunday Call*. They had no reason to be other than proud, for they were attired in the very latest in beachwear (or at least pond-wear), including long stockings beneath their skirted bathing dresses.

Nine

CONTRASTS
THROUGH TIME

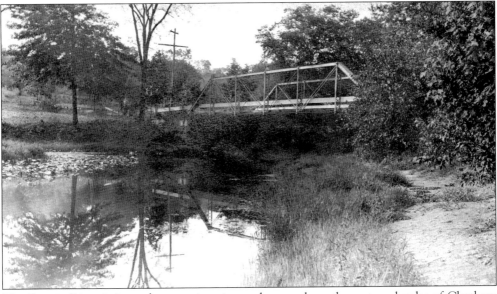

The Passaic River is in no hurry as it twists and turns along the eastern border of Chatham Township, following a bed carved out 30,000 or more years ago. In prehistoric days, the river flowed south and east through the present-day Short Hills Gap in the Watchung Mountains. That was closed by the glacier that covered the land until about 40,000 years ago. After the glacier moved away, the flow became generally northward toward the Falls of the Passaic at Paterson. In Chatham Township's recorded history (particularly in the early 20th century), the riverbanks provided power for many mills. Today, all the mills have vanished. This bridge is one of the few reminders of the years when the river was busy, varied, and filled with the joyous sounds of swimming, boating, canoeing, and fishing. There is great contrast between the Passaic River as it was 75 or more years ago and as it is today.

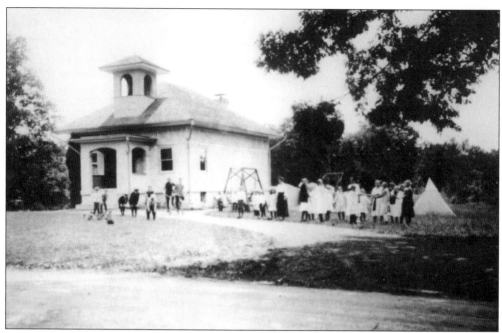

A major center of elementary education was the first Southern Boulevard School (also known as the Noe Farm School), located at the present King James Nursing Home site. This *c.* 1916 photograph shows the small, square building and the simple playground that surrounded it. The school featured a bell tower and a porch for students to leave coats and to clean muddy shoes.

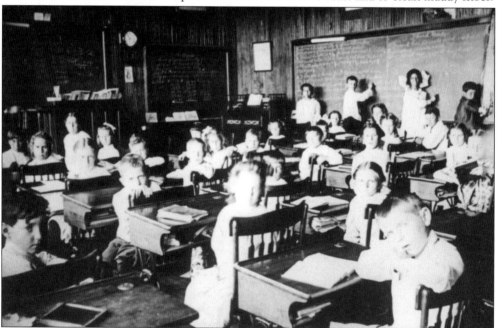

The old Southern Boulevard School was typical of one-room schools of the period. Nearly 30 youngsters met daily, sitting on uncomfortable seats behind an old-fashioned desk. Interior light was slight, and ventilation was poor. The blackboards were the main visual aid. The room had few amenities, even for a vintage building.

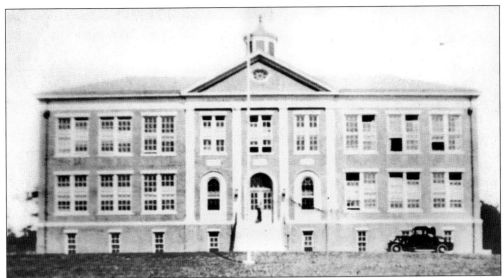

The new Southern Boulevard School has been the basis for elementary education since 1928, when it gathered 29 students from the old Southern Boulevard School, 67 from Mount Vernon School (Red Brick School), and 66 from the Green Village School. The pseudo-Colonial architecture fronted good-sized classrooms, good natural light, and a spacious playground.

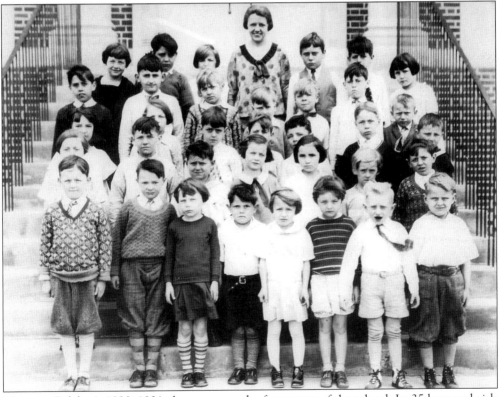

Margaret Belcher's 1930–1931 class poses on the front steps of the school. Its 35 boys and girls easily topped the total enrollment at the first Southern Boulevard School. Belcher taught for 40 years in the Chatham Township system.

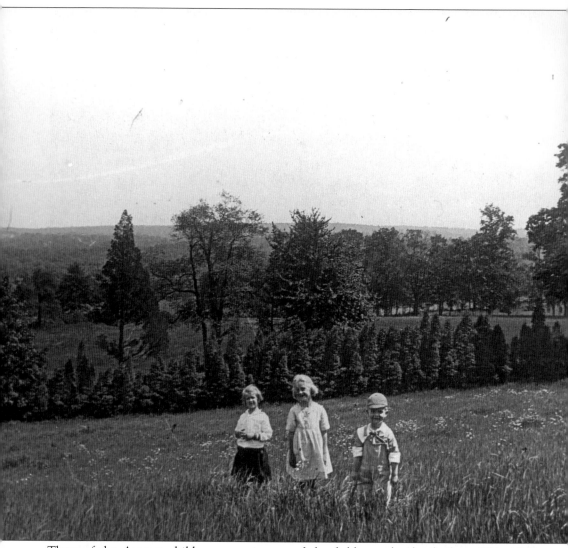

Three of the Averett children pause in one of the fields on the family farm. This 1920s photograph looks south toward the Passaic River. Behind the children are the widespread, rolling pastures of the Averett estate. This kind of pastoral vista was common in Chatham Township at the time.

Where have all of Chatham Township's great panoramas gone? They have been covered over by the ample evidence of the rapid quest for attractive sites on which to build its Chatham Glen (below). The Baker Firestone buildings cover much of the landscape shown on the previous page.

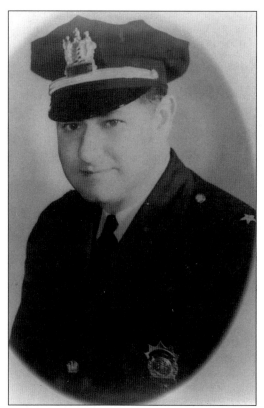

Rustem Bey (left), son of Madame Bey (see page 63), was Chatham Township's entire police department (including chief of police) when he was hired in 1937. He was likely the only policeman in America who spoke three languages fluently. He remained as chief until he died in office in April 1961. By then, the department had expanded to handle the sweeping changes that were spreading across the township. In more recent years, more than 20 officers made up the department, headed by Thomas Ramsey (below, in the white shirt), who was chief in the 1990s.

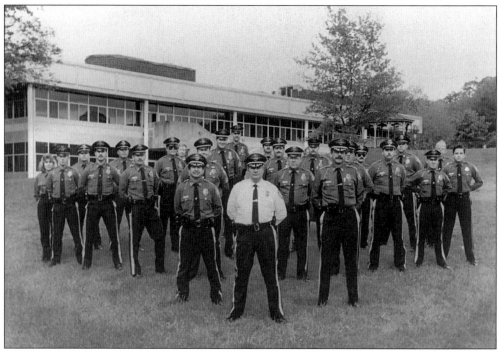

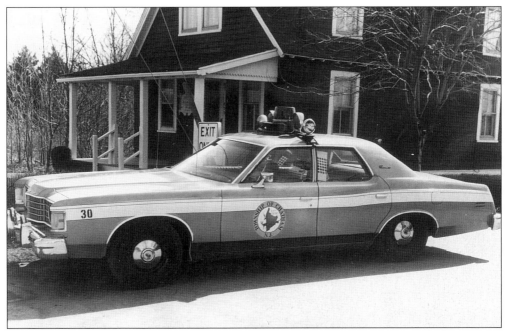

In the mid-1970s, the township police department still operated out of the old house on Southern Boulevard (above). The new police station, at 401 Southern Boulevard, was dedicated on November 6, 1976. In 1961, five members of the Chatham Township Emergency Squad (below) pose proudly beside their up-to-date rig.

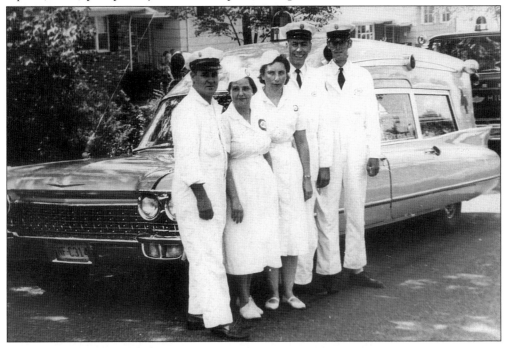

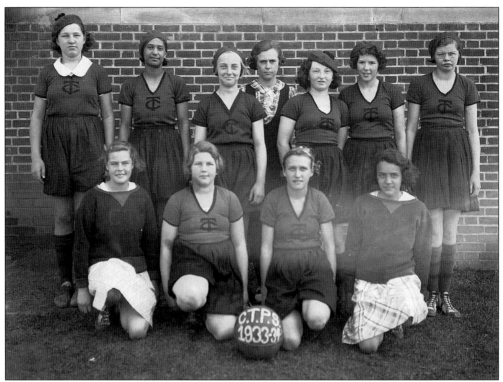

Athletics became a vital part of Southern Boulevard School's program in the early 1930s. The girl's basketball team (above) had eight players and two cheerleaders (on either side of front row). Boy's baseball (below) was in full swing as the 1930s opened. The team apparently played in everyday clothes, with sneakers instead of spikes.

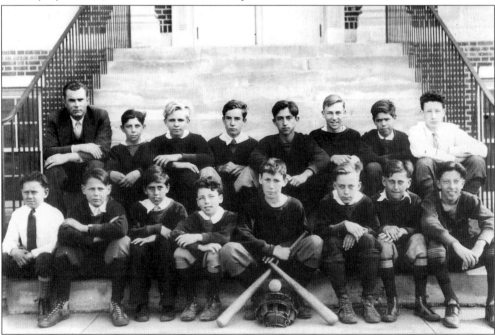

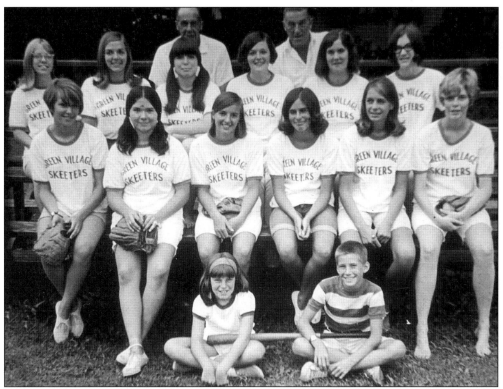

Sports for Chatham's girls and boys today are a far cry from the poorly uniformed and inadequately equipped teams of their grandmothers and grandfathers. The sprightly Green Village Skeeters (above) are sponsored by the Green Village Fire Department. Equally well prepared for action is the football team (below) sponsored by the Police Athletic League.

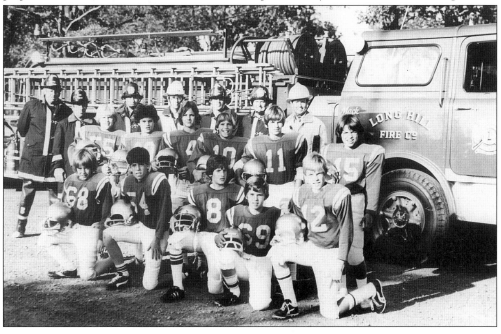

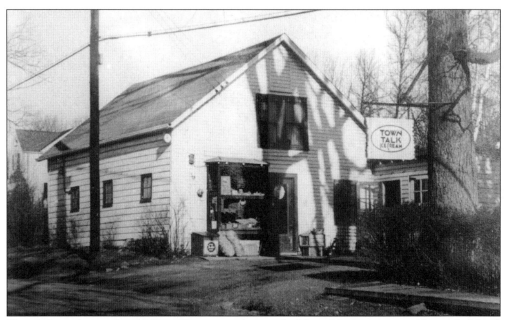

Harry's Store (opened in 1943 on Fairmount Avenue by Harry Harootunian and his wife, Mary) soon became far more than a store. The couple operated a post office substation where area residents picked up their mail. They let the fire department put a siren atop the building, to be sounded in case of fire. The store also became a gathering place. When Harry faced difficulty in securing a liquor license, neighbors rallied in support and Harry received the license.

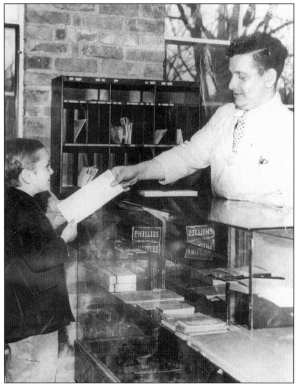

Harry Harootunian enjoyed giving mail to his young customers, as shown here. He also balanced food and prime meat sales with selling liquor; his license was the first in Chatham Township. Harry was a volunteer fireman and helped Chief Bey in his police duties. He gave liberally to local causes and several times sponsored a pig roast for township employees. The Harootunians sold the business in the late 1960s. It is now the Fairmount Deli.

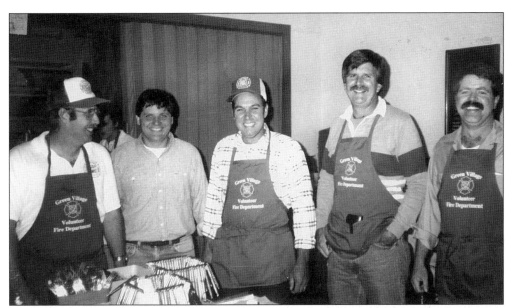

Intended as fundraisers, dinners sponsored by the Green Village Fire Department (above) and the Long Hill Fire Department (below) also became major social events in any year. The emphasis in Green Village has been on the Steak and Brew Dinner. In Long Hill, turkey dinners are the order of the day.

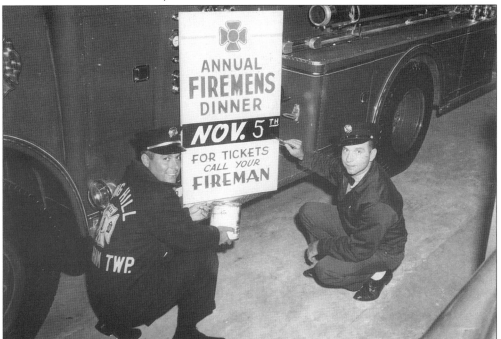

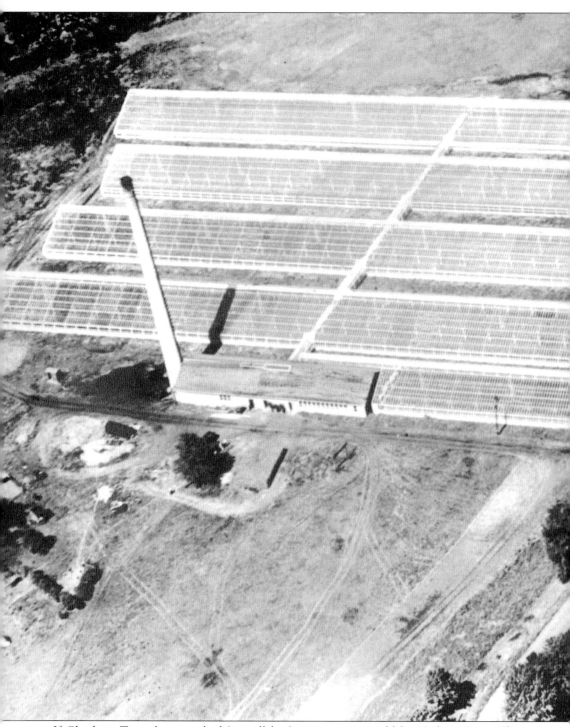

If Chatham Township ever had (or still has) a center, it would be Hickory Tree. This rare photograph shows the Hickory Tree area in the early 1930s. The large greenhouses were built in the late 1920s by Edward Behre, a well-known area rose grower. The opening of the greenhouses coincided with the Great Depression, which caused a precipitous drop in rose sales.

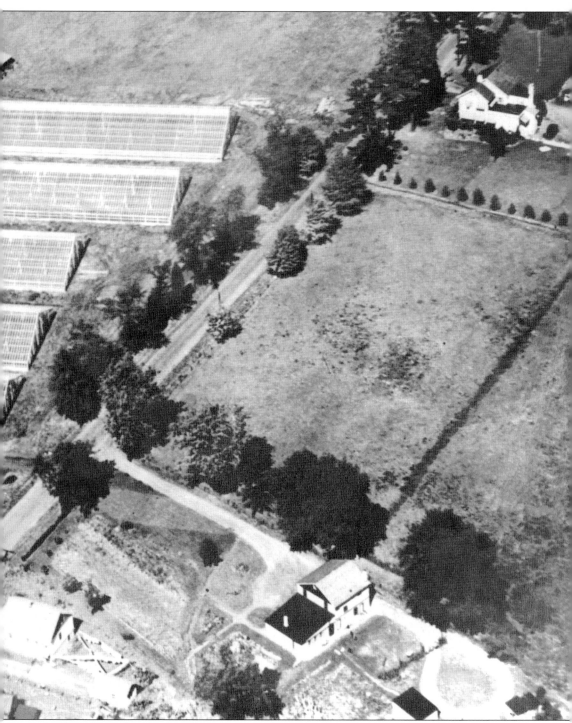

Soon after, the Behre business collapsed. The greenhouses in this photograph have been replaced by a large complex of apartments. The area in the front of the greenhouses is where the Hickory Tree shopping center was built in the 1970s. The area is shown on the next two pages in a modern aerial photograph.

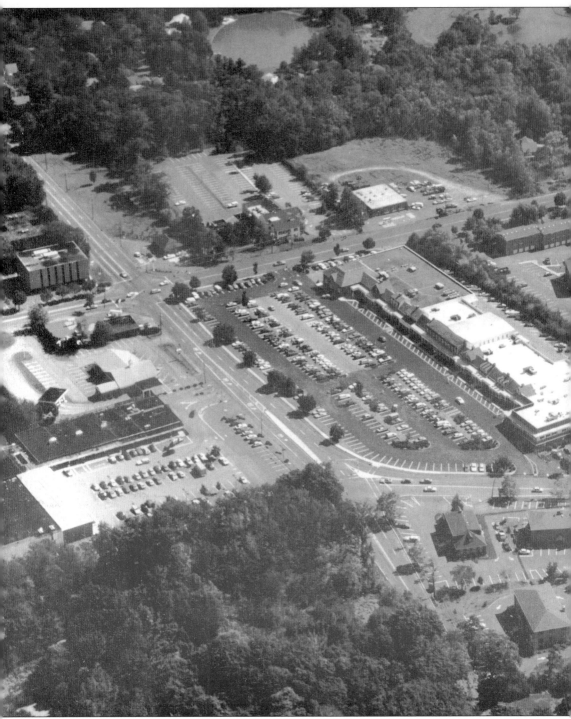

The Hickory Tree shopping center, as it now looks, is shown from the northwest, but it is easy to compare the modern view with the days of the greenhouses. The several apartment buildings clustered on the right are situated almost exactly where the once-extensive rose business flourished, even if only briefly. The shopping center is on the former open field to the north of

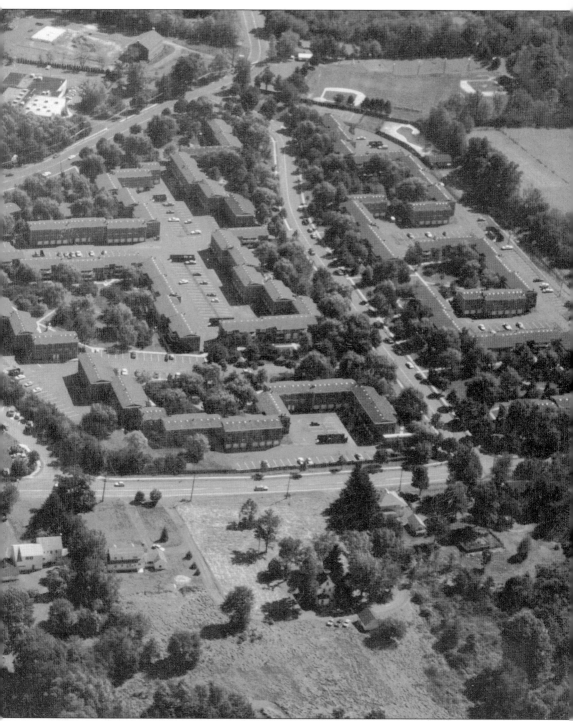

the old greenhouse section. Charlie Brown's Restaurant (upper left corner) is easy to identify by anyone who knows the area. In the photograph on the preceding pages, this building was in place but was a private residence.

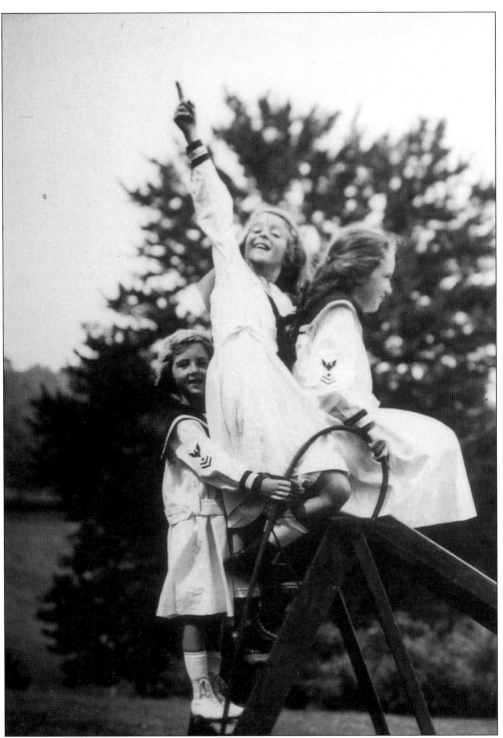

Long before being number one (signified by a raised index finger) became a sporting event staple, the three Averett girls gave buoyant emphasis to their feelings about life in general—and, hopefully, about Chatham Township in particular.